© MOTLEY MAGAZINE
&
© WORM LITERATURE MMXXII

motley mag
volume 2
(issue 2)

First edition: December, 2022

Cover design: João Bresler

© All rights reserved

Printed somewhere on Earth i hope

ISBN: 978-1-4710-0124-6.

Worm Literature
MMXXII

Motley Mag
VOL.2
houghts and visuals
elected

Editors And Collaborators Of The MOTLEY MAGAZINE:

EDITOR. João Bresler *@oysterboiwho*

COLLABORATORS.
(in order of appearance, with the first piece being the guide in case of having contributed with multiple pieces)

Hunter *@tomadorodeo* ..4,5
Rob *@sheriff.bones* ..6,7,8,9,68
@agiganticinsect *@mitskihater38*10,11,36,37,57
Myron *@akafujiii* ..12,13
Femboysito *@femboysito* ..19
Eric *@erikycarrotdirtyrat*20,47,60,61
Çangil *@cangilll* ...21,108
Rye *@originalunleaded* ..27
Mia Hudson *@yuckystuffs*30-32
Blue *@jesuisaneika* ..39
Lur Mitxelena *@kcure.lmii*40,41,98
Aaron Oddoye *@aarontheoddone*42,43
Sylvie *@icuffmyjeans* ..50-53
Ruby Jangaard ..58,59
Lucie Orozco *@_cursed_frog_images_*64-67
Vlada *@fourtysundays* ...70,71
Laysa Schat *@skolopendridae*72,73
Aleksandar Gabrovski *@alexandar_gabrovski*74,75
Giacomo Nasta *@caracollo.comics*79-84
Anastasia *@calc1te_ch1roptera*86
Italo *@art.by.italo* ..91,92
Con Essa *@orenjijusuu_* ...96,97
Elsa *@sobek_oficial* ..104,105

All other pieces have been written, drawn, edited, collaged, manipulated or curated by the editor.

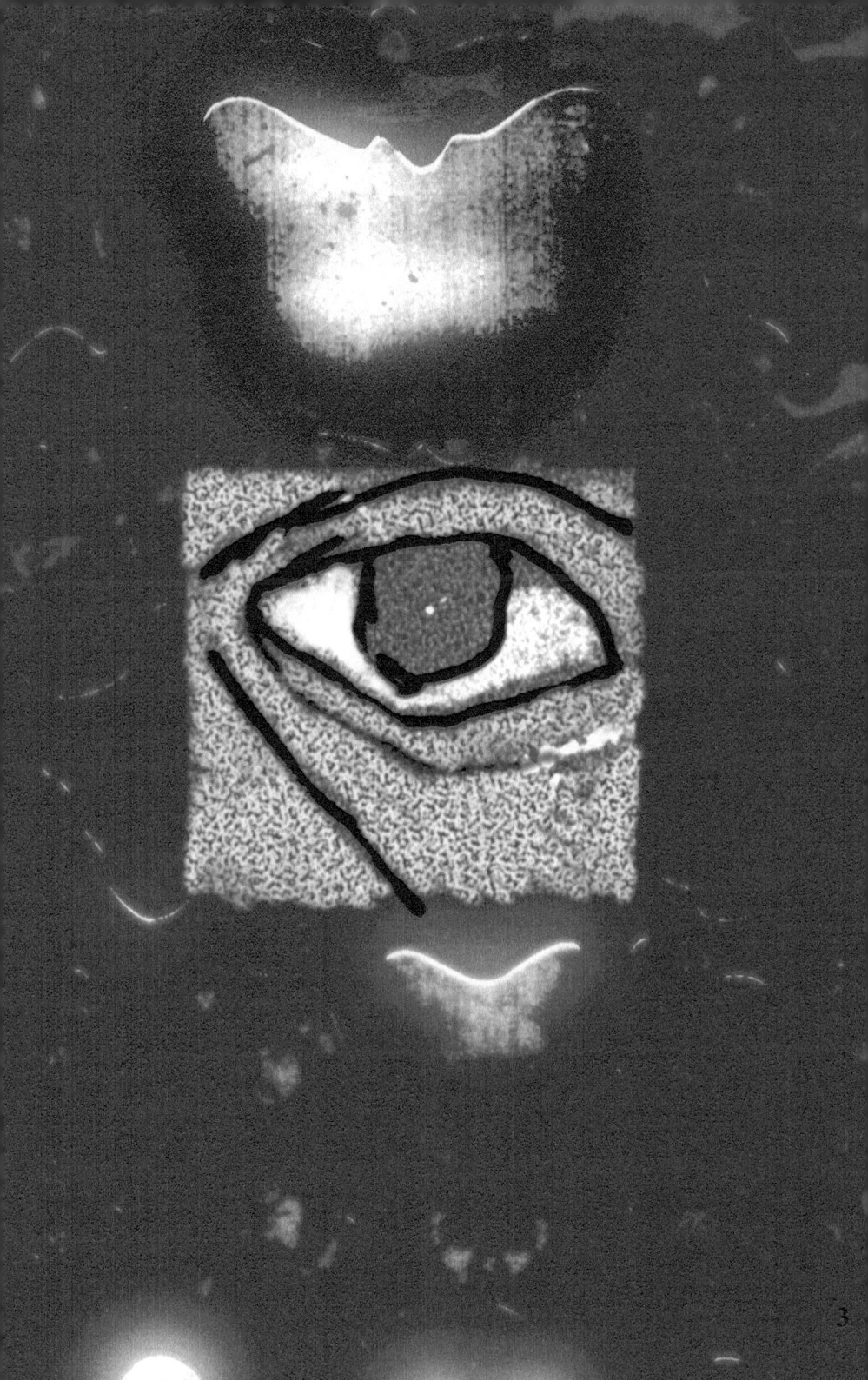

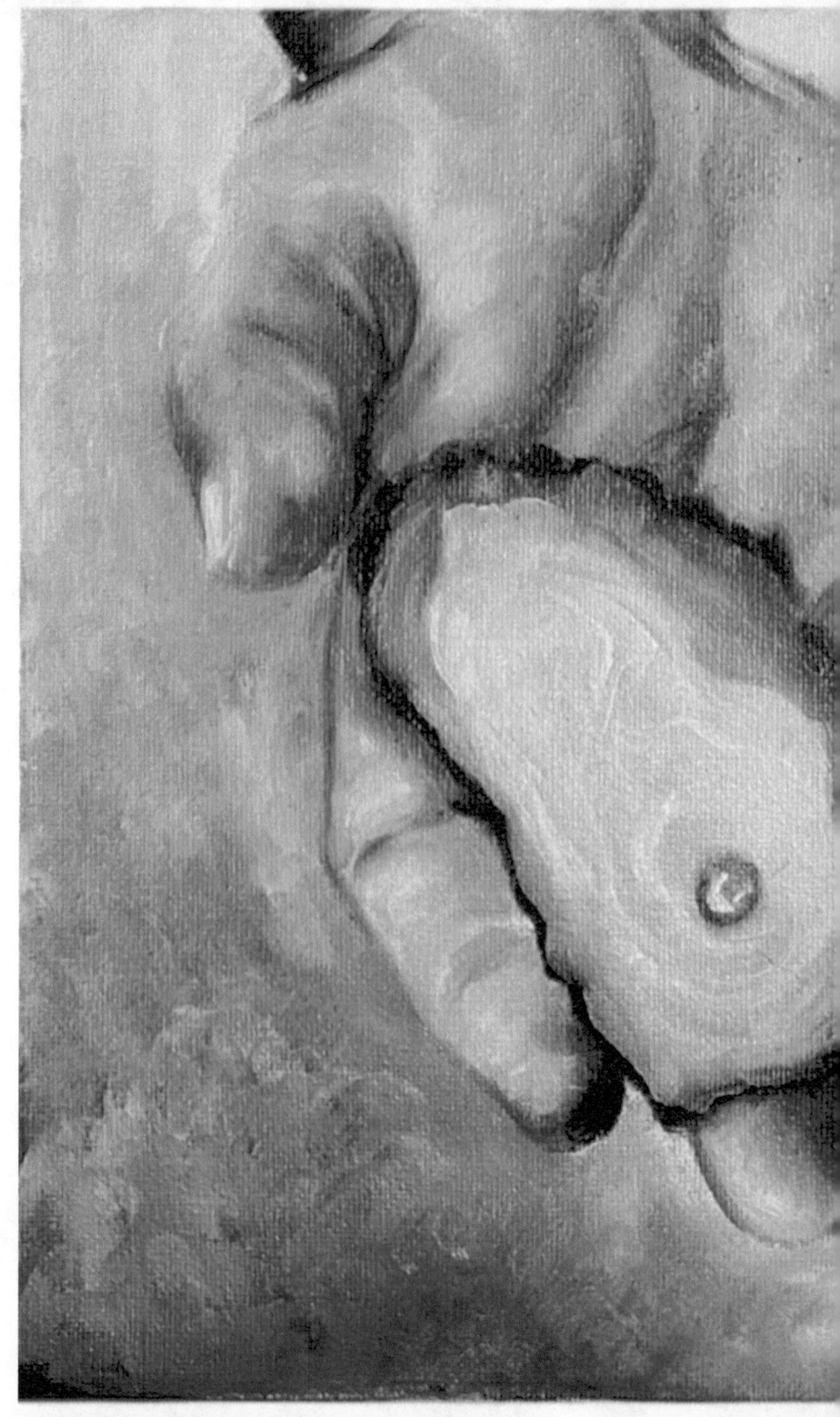

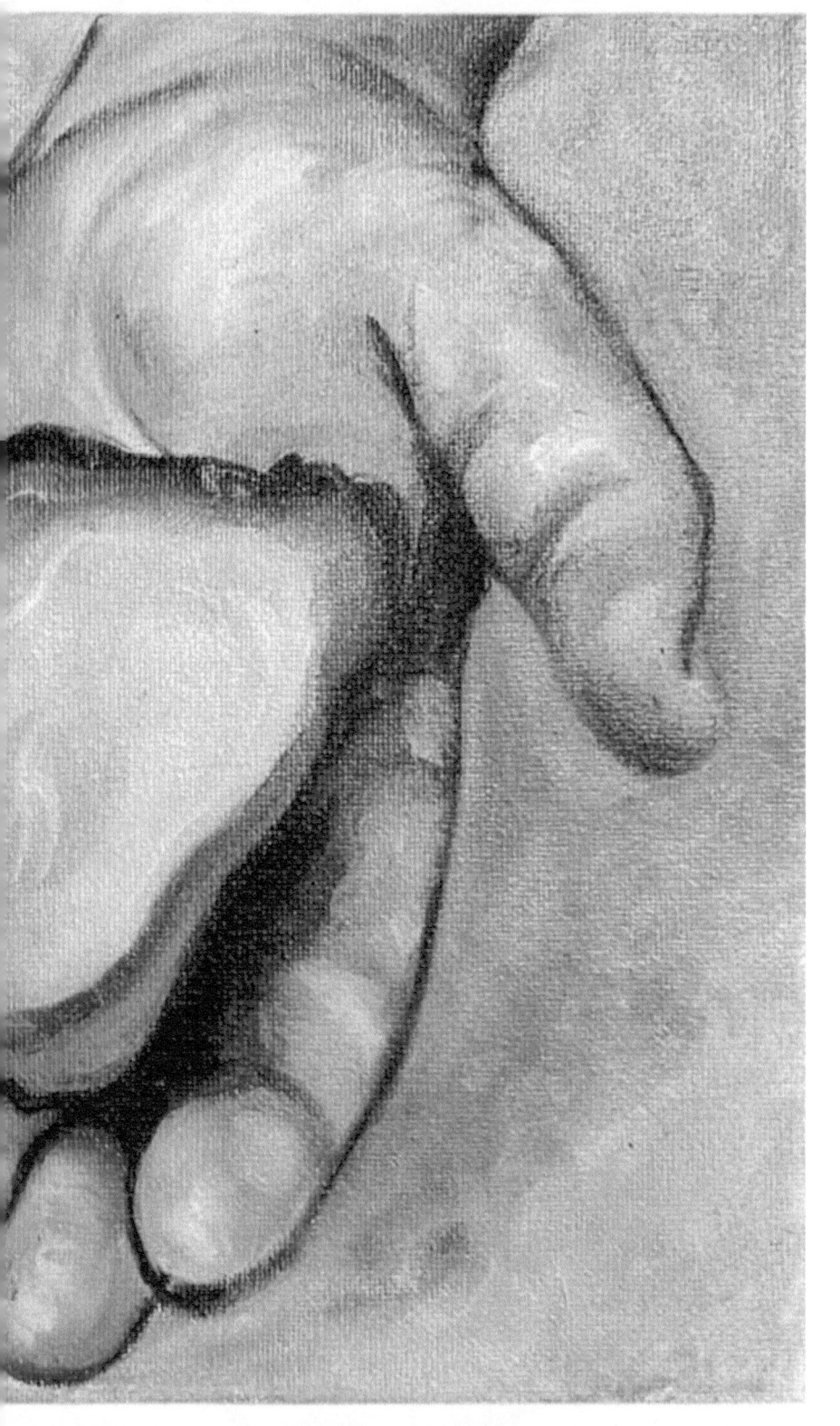

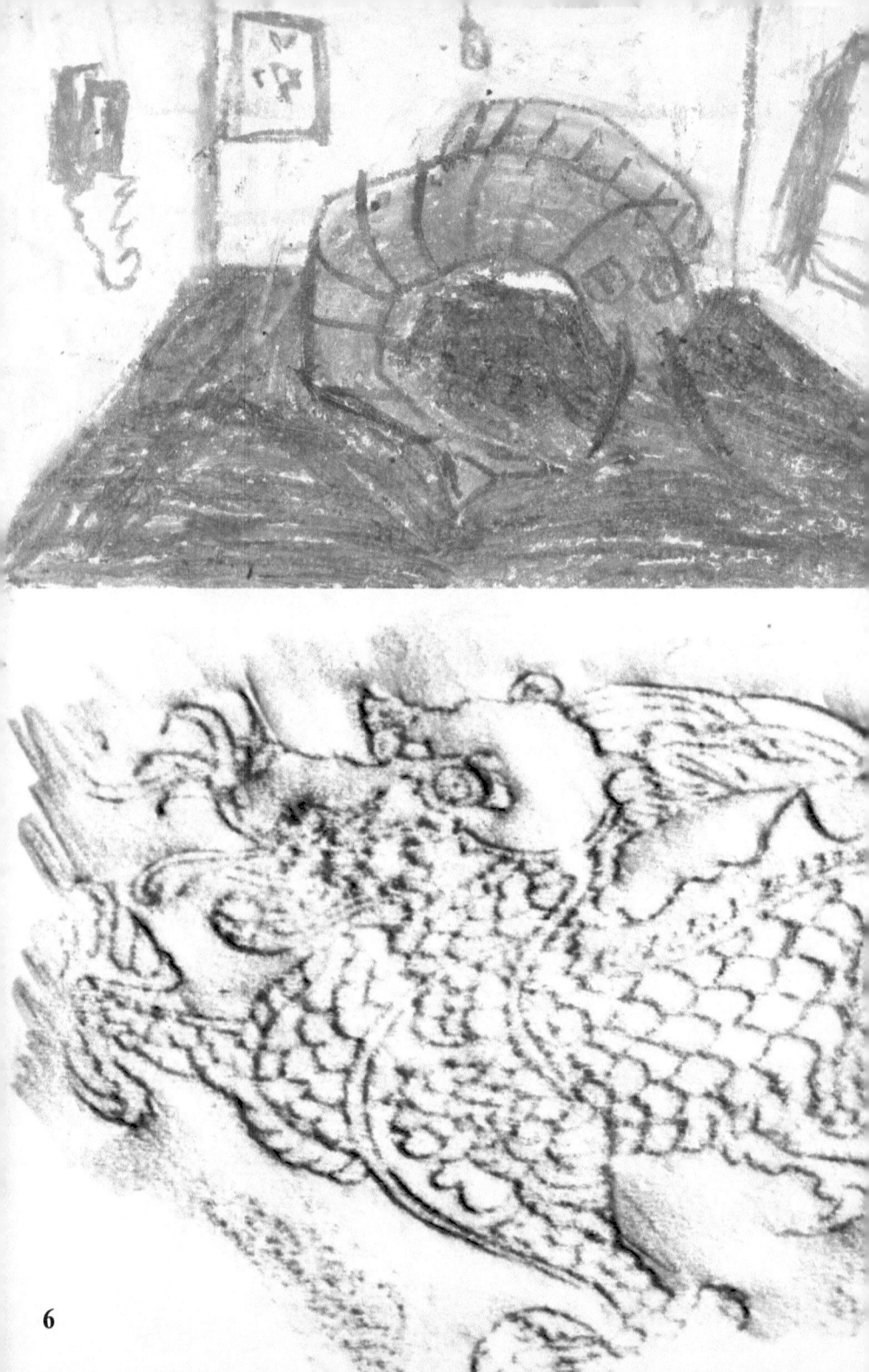

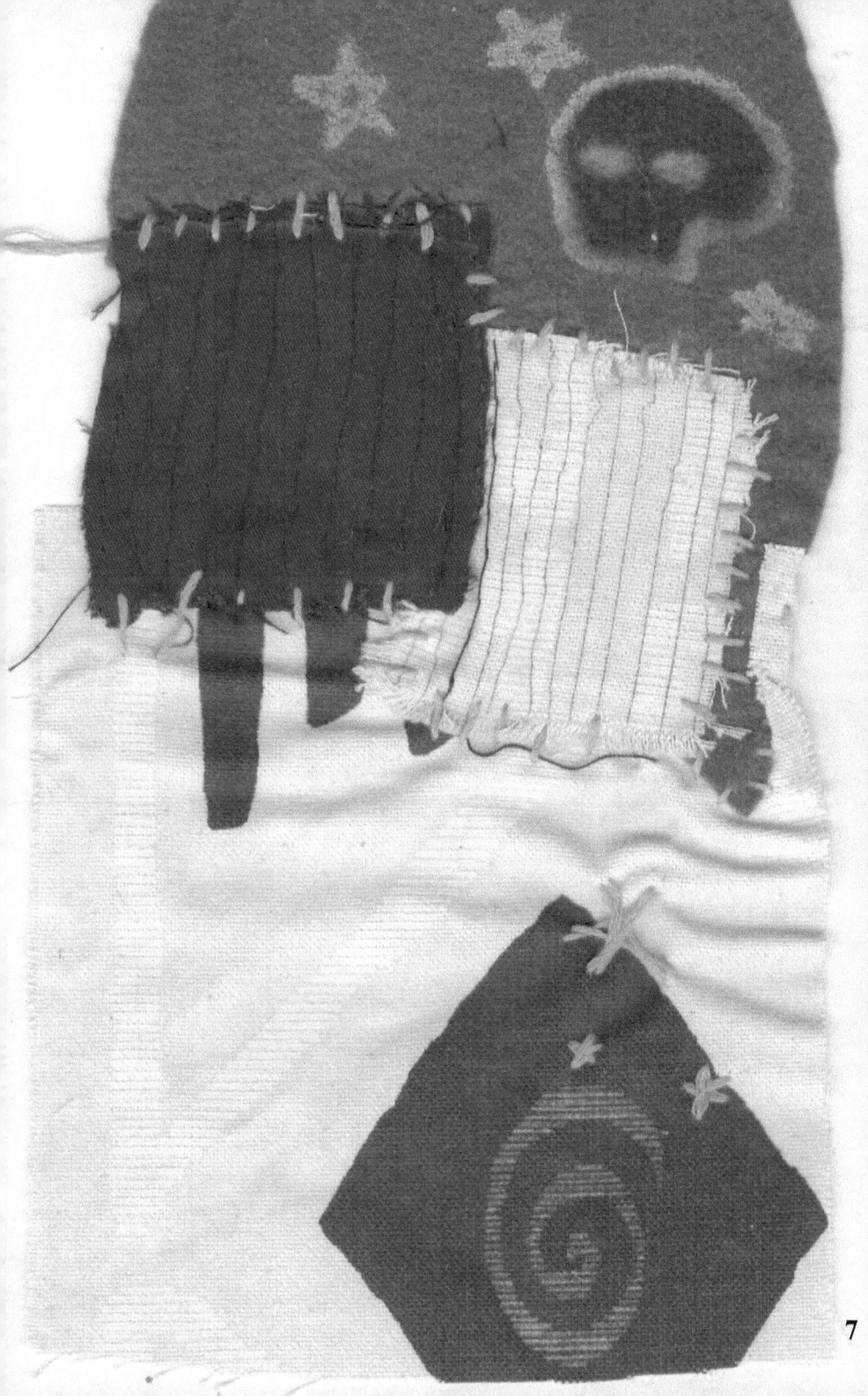

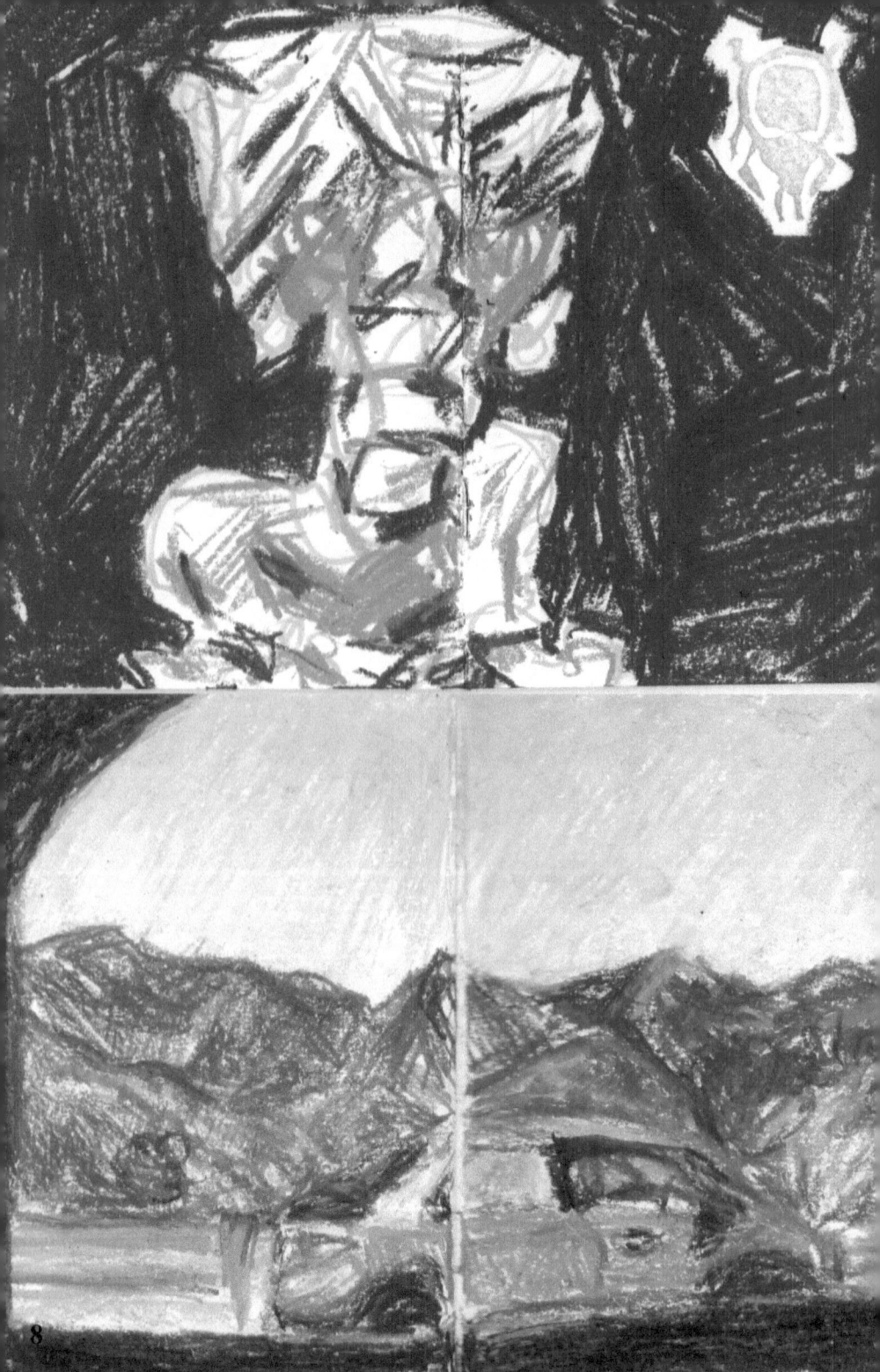

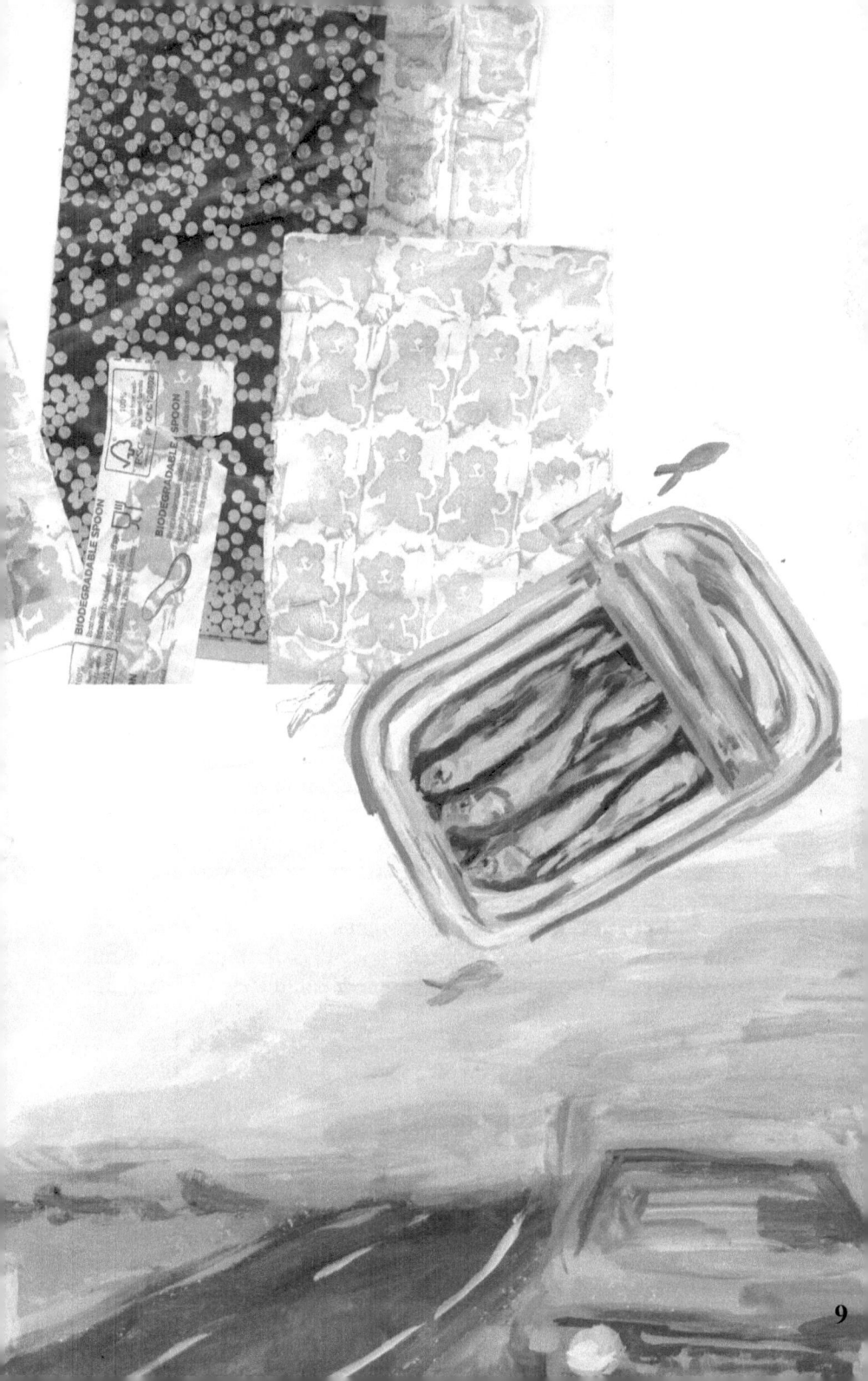

Short Depiction of A Roommate

By mid August, most of the many boxes had been sealed and stored neatly at the edges of the rooms. Silverware, various cutlery, a Turkish windchime, small, mass-produced paintings, mirrors, a variety of brushes (toothbrushes, hairbrushes, a wire-brush for a cat) and other ephemera had all been confined to the isolation of stationery cardboard boxes. The things that remained, things too heavy to be carried off or boxed up, laid as a sort of furniture display showcase at the center of the room, devoid of any defining characteristics of life.
From his position in the doorway, he could not only see the entire room in its barren scarcity, but beyond it as well; a series of doorways, wall corners and breakfast-nooks framed a pale rectangle on the dead opposite wall of the apartment. The rectangle seemed less of a door or a window, but a completely vacant space in reality altogether. Lacking color or depth, a pure, shining white five-by-three-foot hole in the Earth was carved into the wall. It hurt the eyes to look at.
The landlord's voice is shrill and out of breath when she rounds the stairs.
"Absolutely charming, isn't it?" She muscles her way past herself to stand in the middle of the gutted room; the kitchen arch leans, the wall corners bloat; the magnificent white void now takes up the space around and inside the kind landlord. She speaks in a distant hum.
"It will not get better than this – not for you, not for anyone. Most apartments do not come with a full bath, much less a full laundry set, imagine that," she had now completely eclipsed that vacant space, which seemed to flatten her inside of it – the perspective of everything, window ledges, doorways, breakfast nooks, walls, boxes, boxes, boxes seemed to fall away completely, "not having to go to a coin laundry. Your own laundrette!" His own laundrette.
She is now somewhere within the house, but her voice is indistinct. It is hard to tell if she stands four feet away, or fifty.

"You know, for laundry." For his laundry. His own in-house washer and dryer set. Perhaps it chimes when the laundry is finished. He approaches it, the great threshold of white nothing, and leans his head out of the hole. His eyes tweak and shirk away from the holy brightness, and there is a noticeable absence of wind. He sees the dark curve of an extremely wide and intricate highway; first, the darkness of the road eats through the flashbang of white. Then other shapes come into view, several slim crossroads that merge here and there, highway exits that branch off and curve back into each other, multiple swirly overpasses.

The grandeur of urban city planning only intrigues him for a short moment. Directly across the street, encircled by the outskirts and exits of a roundabout, stands a massive concrete building. The neighboring building has many dark slots built into it – not quite door-shaped, as they seem to lead to nothing at all – but each passage has a railless, decorless, vague slope of balcony beneath it; support for whatever tenant of darkness to relax on his balcony.

These details, the blurry white slivers of balconies and the over-industrial architecture of the apartment complex across the street, are also insignificant to the viewer. He gapes, instead at the white, five-by-three foot hole that blows clean through the concrete building. It stands uniform with the others – minus a line for a balcony – but appears significantly more far away than everything else. There is nothing on the other end of it. The sky presses heavily against the highways, forces the confines of his body onto himself. The wind picks up, not throwing itself around him, but instead collecting the dust of an amazingly wide, empty highway. The wind blows through the Earth via a five-by-three hole in everything

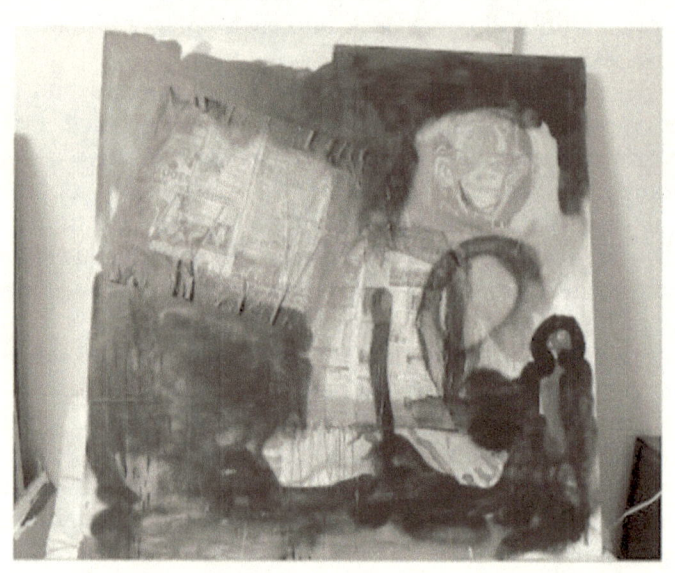

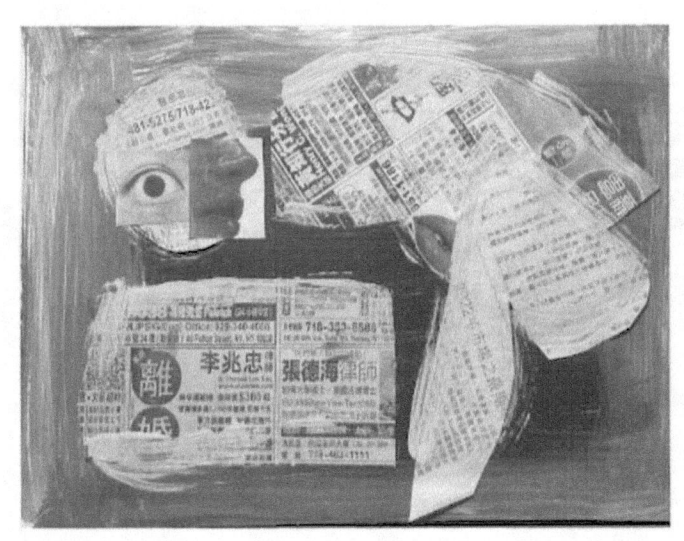

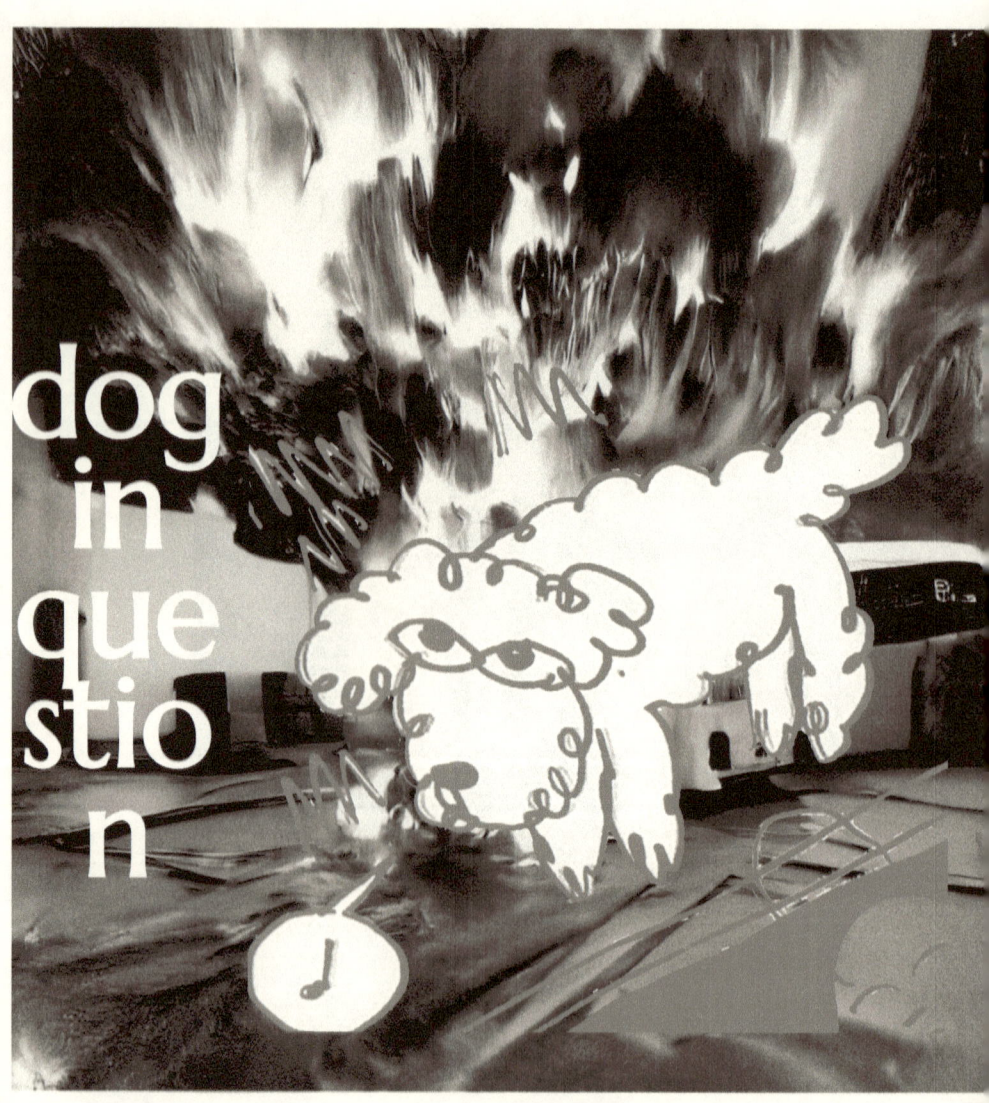

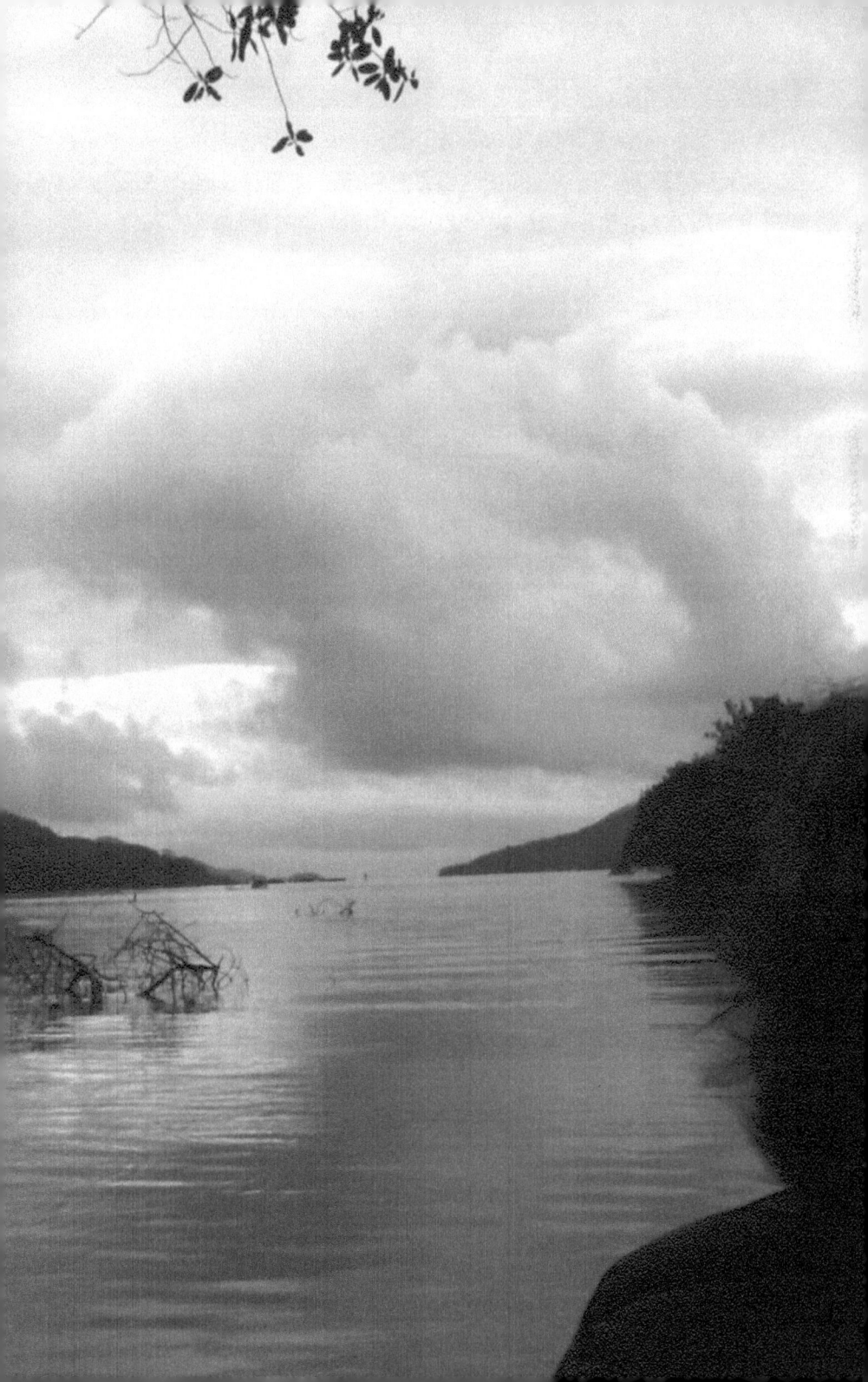

I didn't see you
That's not supposed to hurt,
How could i love someone without their existence, could i?
But you saw me and you hugged me in the entrance of the green stairs that went down to the big earthworm that carries people, that cough, to their jobs
You weren't thinking about people that go to jobs and cough, i dint't know who you were then, i don't know if i know who you are, now

Then i hugged you, because i wanted to know who you were,

Then we both hugged each other and we merged our arms and you laid your head and now my shoulder wasn't just a shoulder, and i wasn't just me
Arms are warm
Yours are
And then i got rid of the cables and worms that confused and wiggled through my hair

November of breezes and steam coming out of our mouths, like we smoked, but you don't, i don't,
i dislike the feeling of having my father's aroma. i don't dislike my father
He can be there but maybe not when i'm trying cigarettes for the first time

Dog walks on a warm august night, four skies in his two black eyes
Sleep dog, sleep with your four stars in your two black eyes

LIVING IN A SILLY LITTLE STATE OF NOT KNOWING WHY I ALWAYS FUCK IT UP

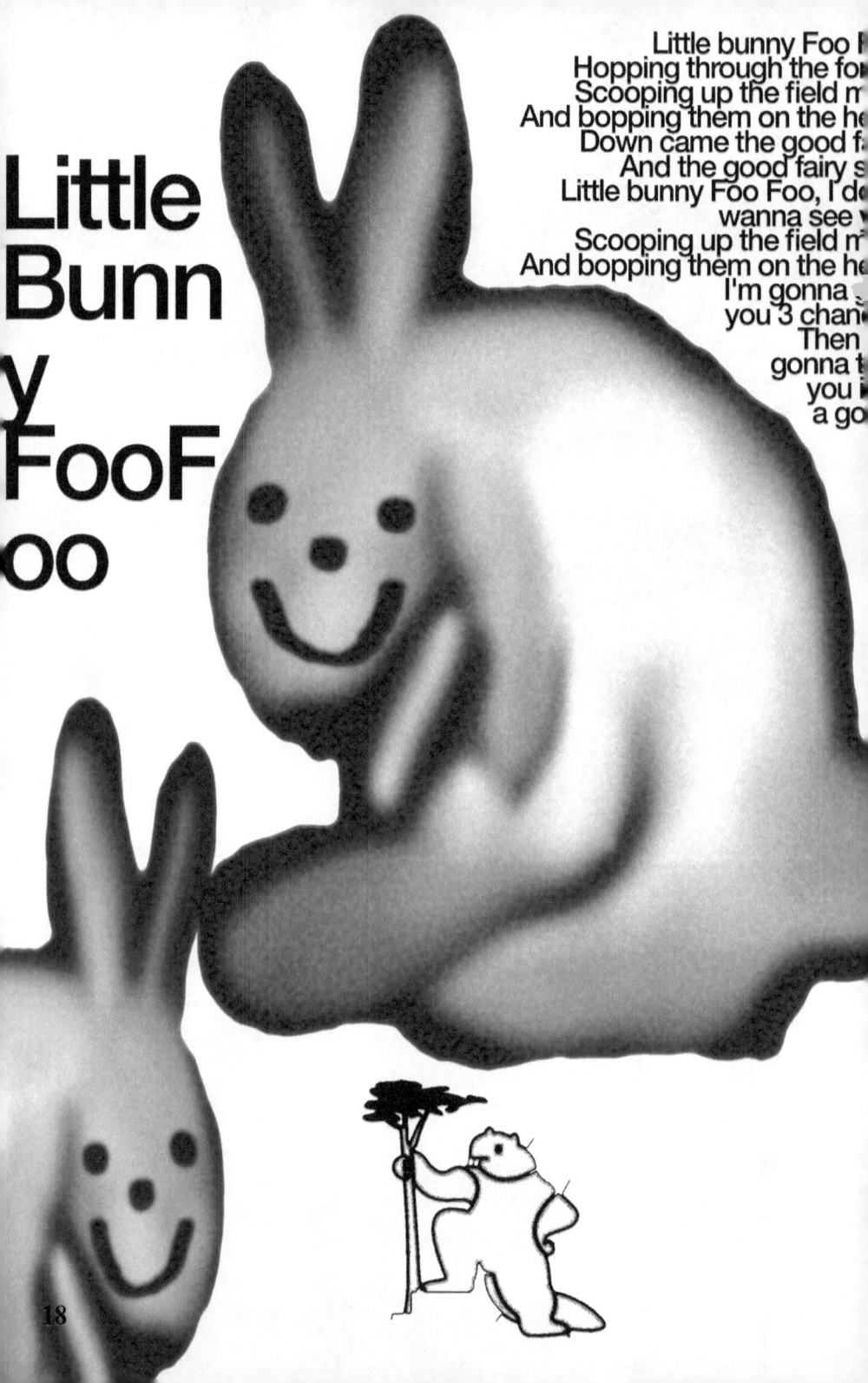

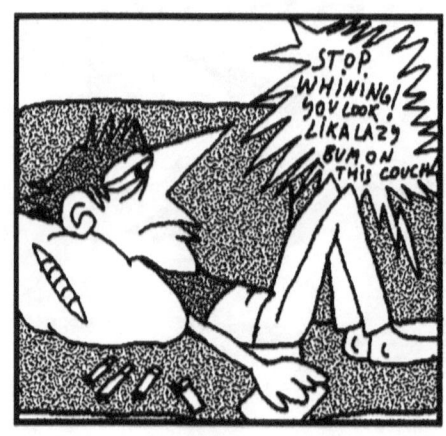
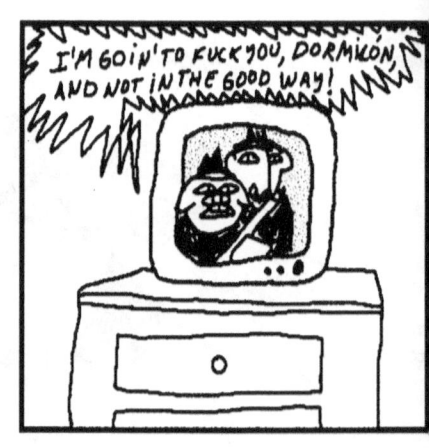

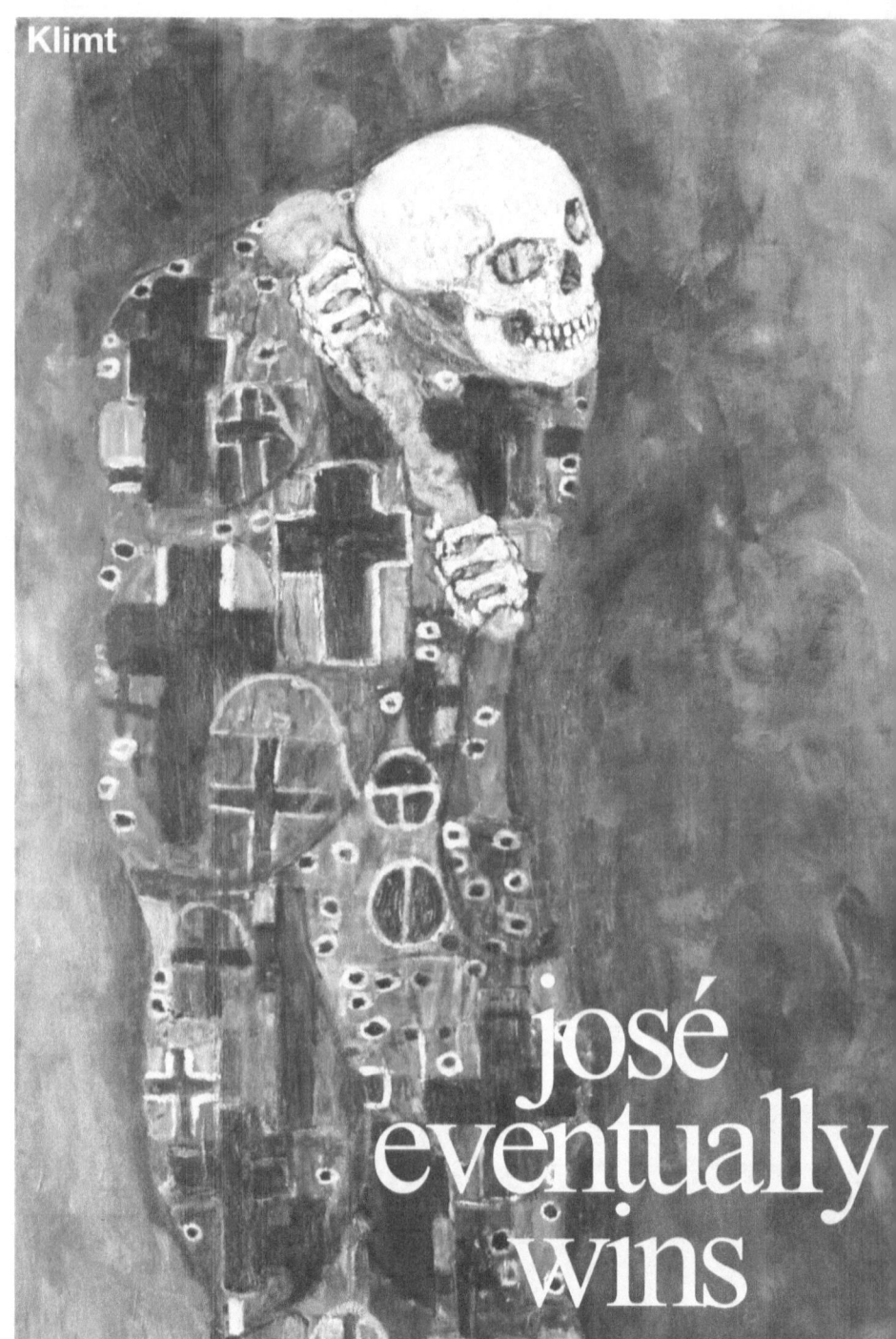

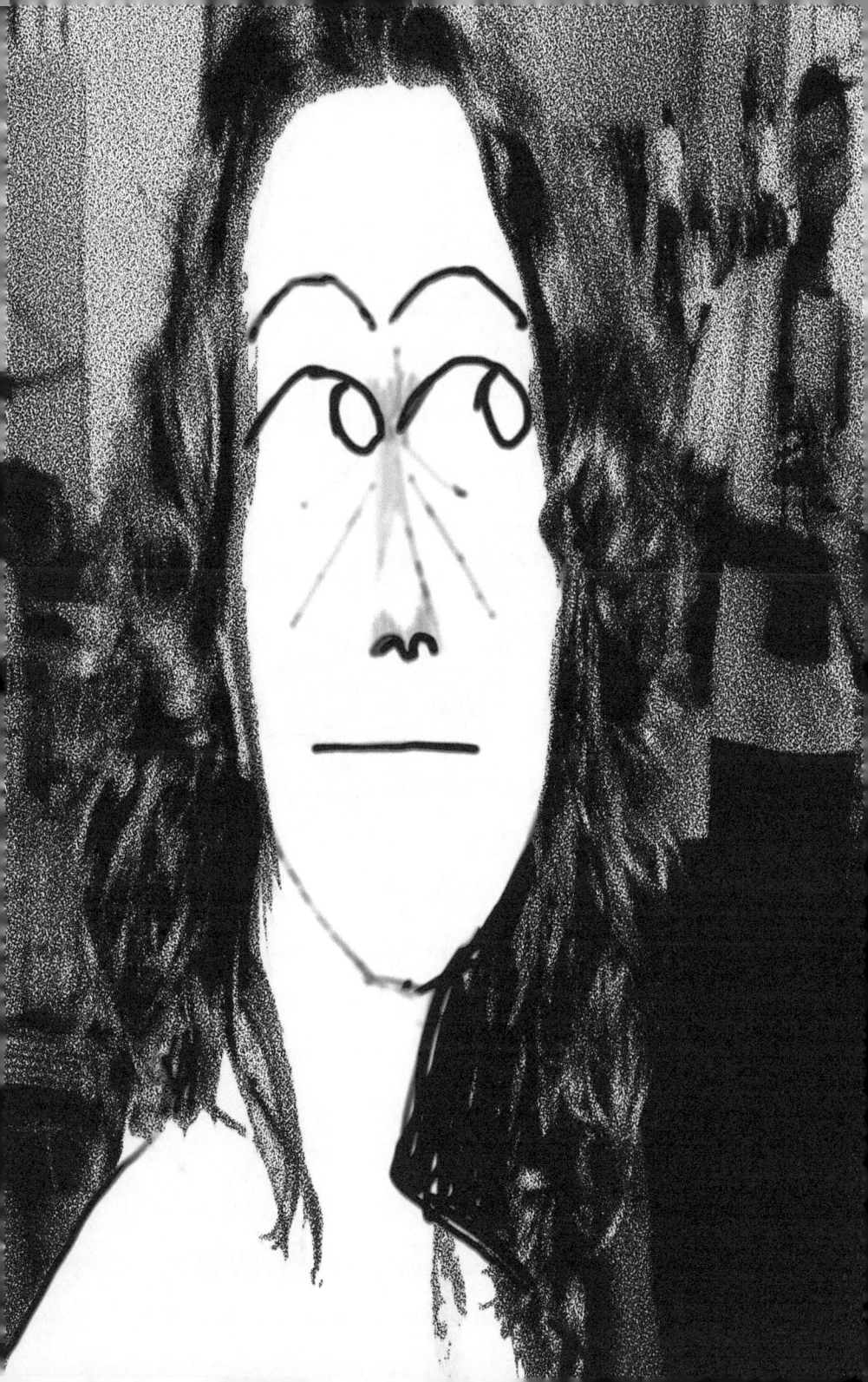

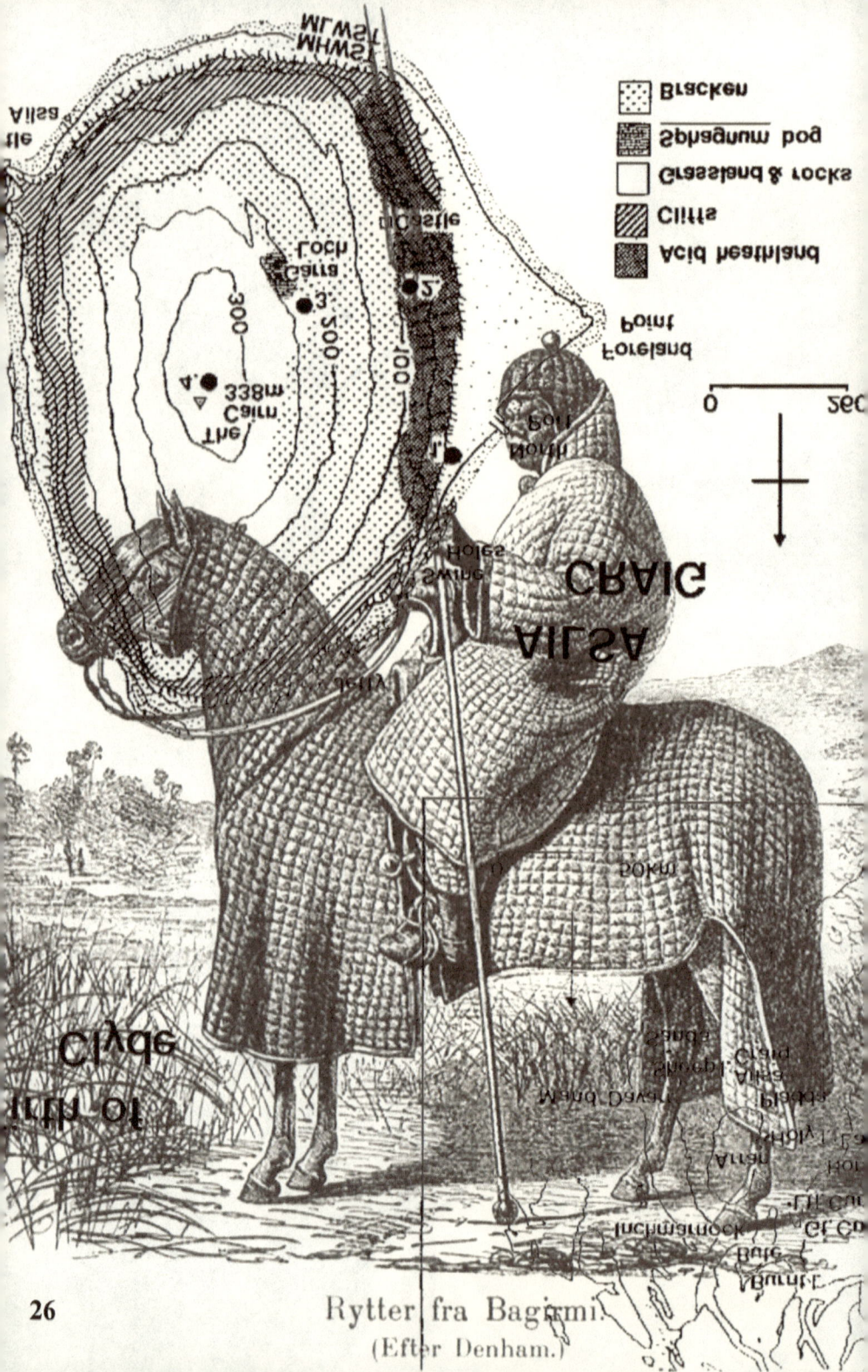

Rytter fra Bagirmi. (Efter Denham.)

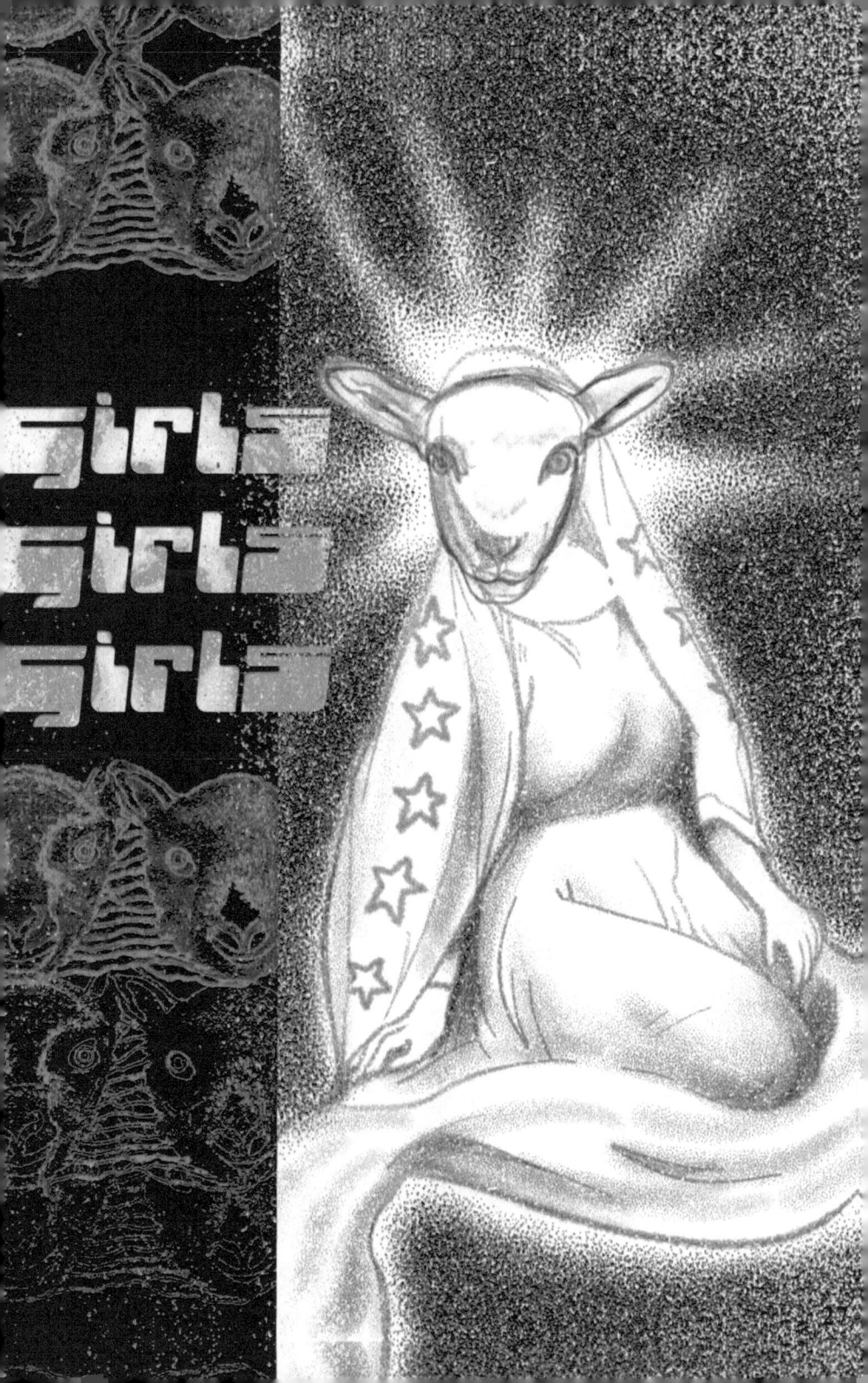

A+

A-

VISIONS ESTENOPEIQUES DE LA
GARDUNYA (EXPOSICIONS D'1 MINUT)

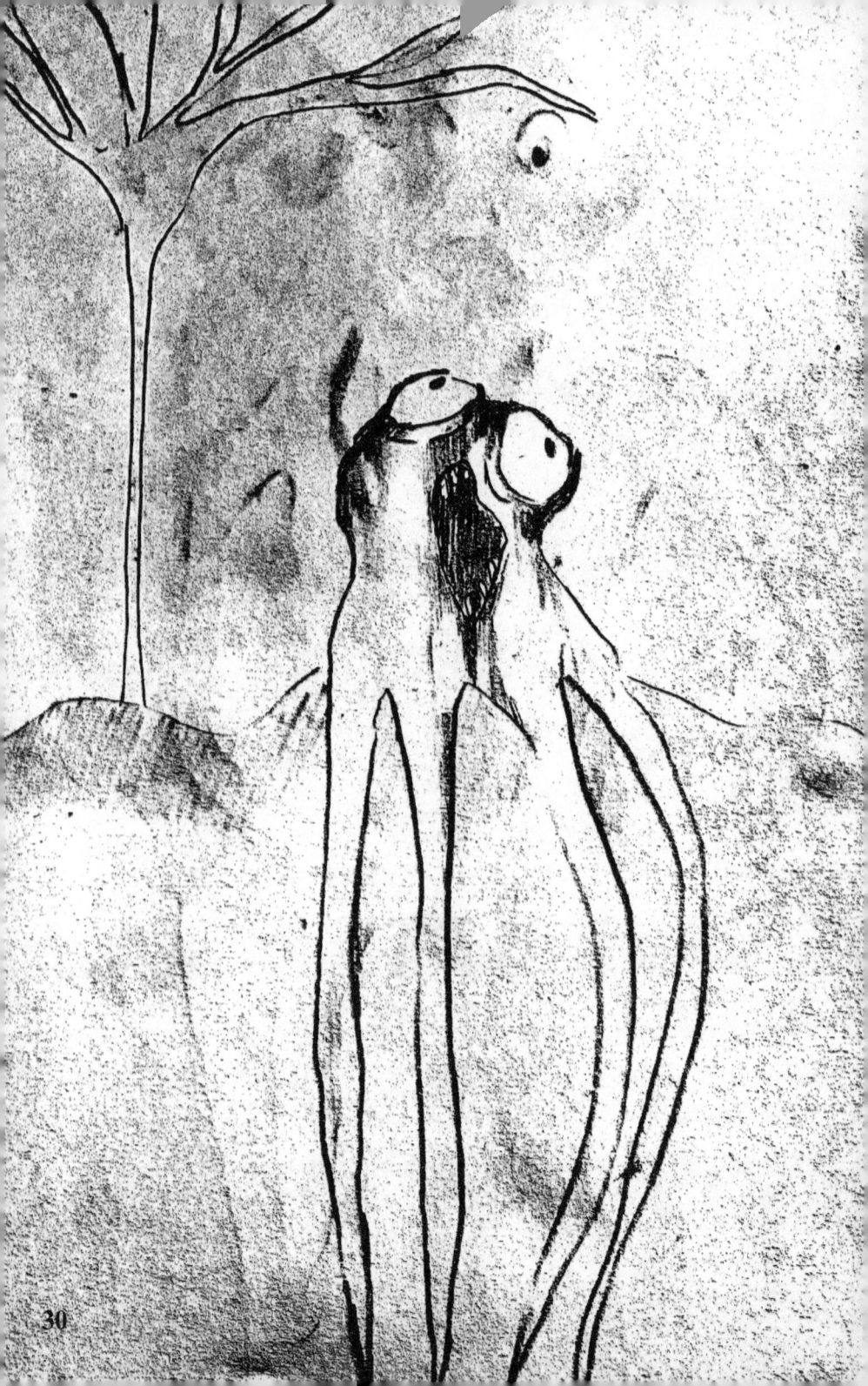

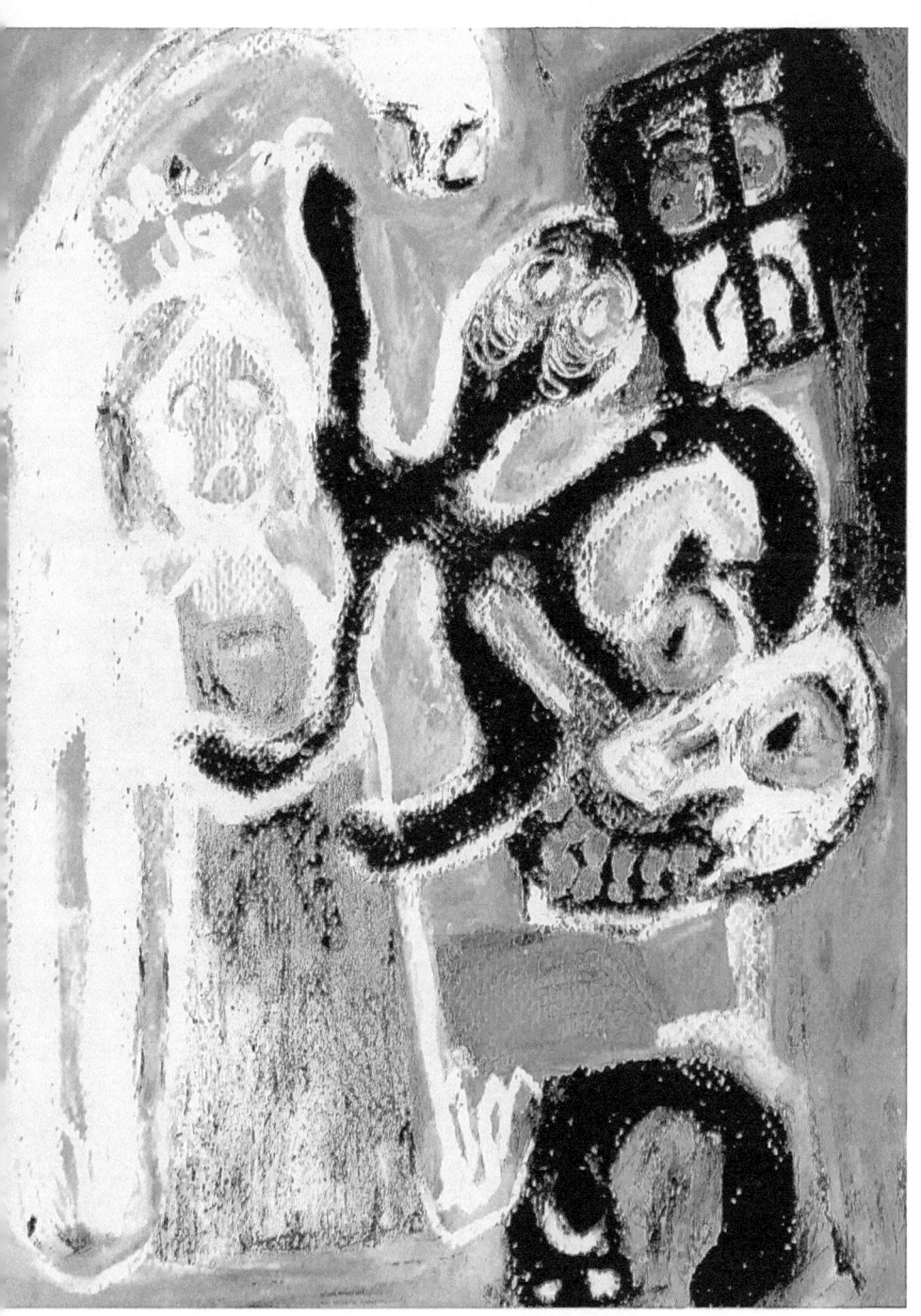

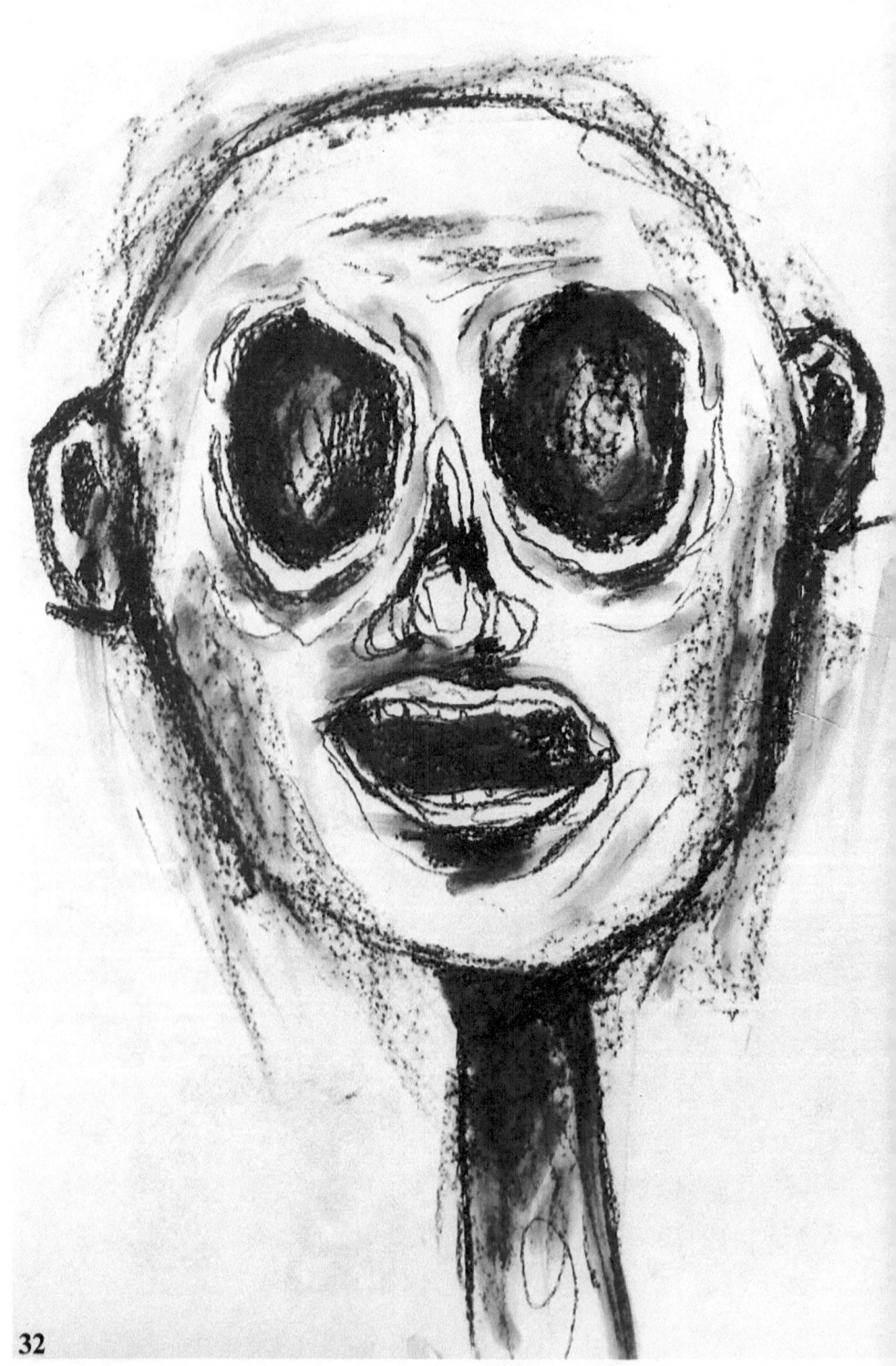

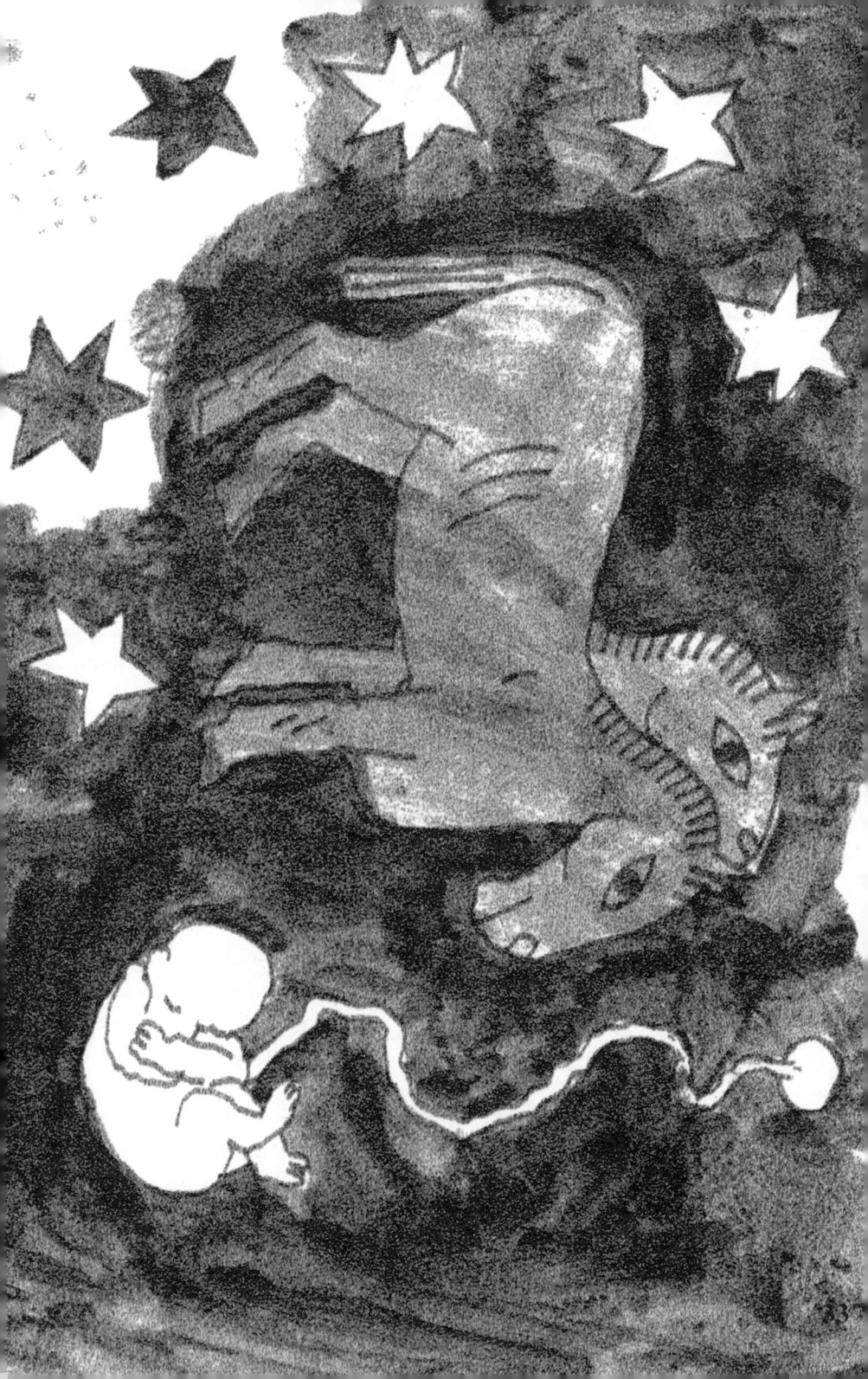

NOTES ON CACTUS FUMES. 1.

After the almost immediate success of the 2nd book from his thesis on the mass production of cactus fume injections, dr. Kovačić was funded to organize an expedition to the locations where the production of the narcotic had grown astonishingly during the last 14 years.

The Croatian doctor formed a group of 7 people including him, me, dr. Thompson, Louis Egbert and the triplets of Northamptonshire. We never found out what each of the triplet's names were, but they always stuck together, so every time we needed them, we would just ask for "the triplets". I befriended dr. Thompson when we crossed the border between Poland and Russia and we had to spend 8 hours in the wagon of a red train, with mattresses so thin they could have disappeared in the middle of the night and we wouldn't have even noticed.

While not being able to sleep, Thompson told me he was just a small child when his whole family vanished during a walk in the surroundings of the Epping forest. He was then adopted by his aunt who was the first British woman to have discovered 3 consecutive new species of amphibians, in 1906. His story was extremely captivating for what we spent the next 8 hours talking about his aunt's notable works and his own experiments on mammals and bioluminescence.

Louis Egbert was more of a reserved man, Kovačić wanted him in the group because he was the grandson of Gilbert Fahnn, author of the 306 effects of cactus fumes on humans, and, having continued his grandfather's work, was the best candidate to understand every psychological and physiological (cactus fumes were one of the first narcotics discovered to alter not only its consumer psychological state but also its physiological state) effect caused by such drug. Apart from that, Louis spent most of the expedition writing on a small notebook, its contents remained a mystery to us.

NOTES ON CACTUS FUMES, II.

-Who are you?- I asked the man, who was a cowboy.
The man looked like he had been standing still for over a millennium, watching a supernova explode, but that didn't give him the right to be rude to his visitors. Yet there I was repeating the same question again and again, the cowboy ignored me.
I felt devastated, I had been travelling for weeks, searching for people to interview for my dissertation on cactus fume injections mass production, and everyone I had stumbled with was into a deep and unending state of apathy. It couldn't be caused the cactus fumes (see 306 effects of cactus fumes on humans by Gilbert Fahnn), there were no cacti in Antarctica, but there weren't any horses either, even so, I was standing in front of a man mounted on a horse.
I would only discover the identity of that man many years later, when I was in a library reading about cases of cactus injections smuggling, and realised there actually were cacti in Antarctica, they had been there since The South-Atlantic Physicoactive Narcotics Expansion, in 1966, and the cowboy was probably just one of the hundreds of smugglers who looked apathetic but were trying their best to not expose that huge drug operation.

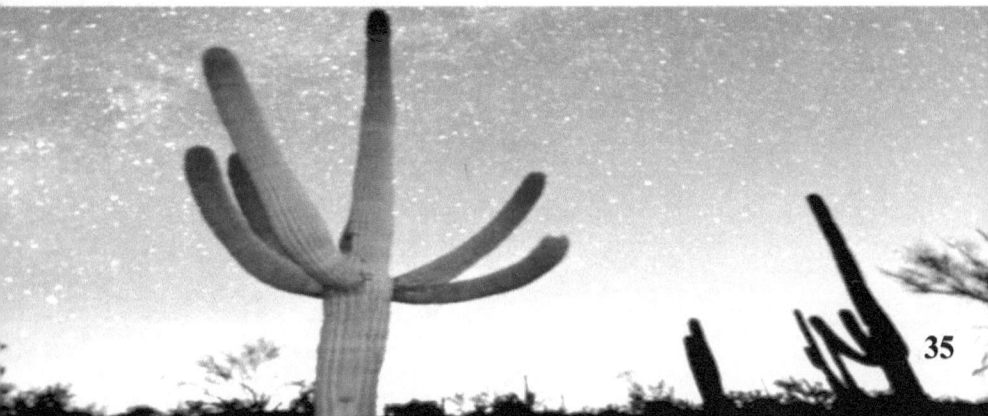

B.

C.

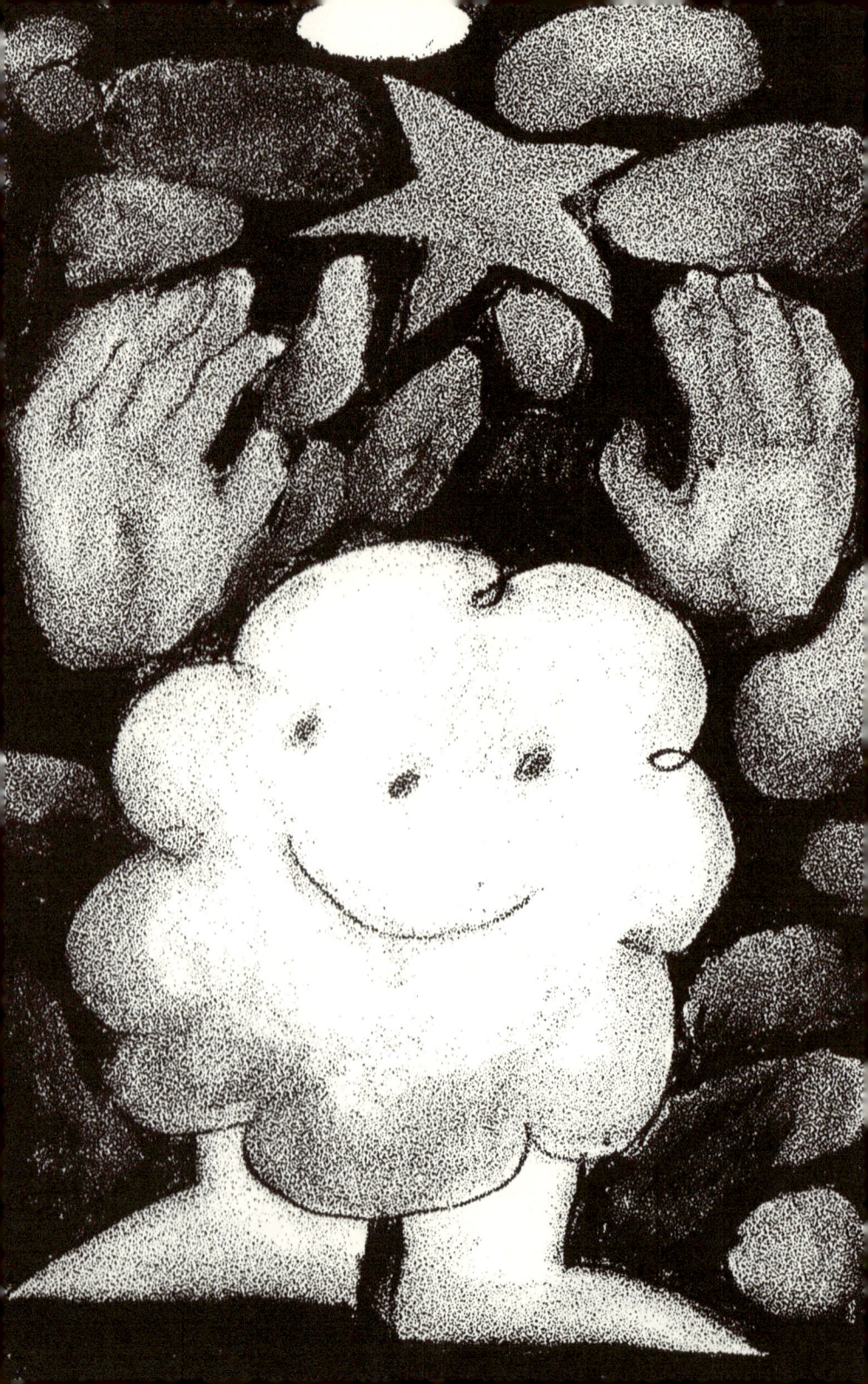

... Hasta que escribo.
No quiero que algo me pueda lastimar
lo que vivo. Y vivo. Escribo sobre ti. Escribo sobre
lo que vivo. Y vivo.

con que sea por amor...

tengo una imagen
empañada de la vida
un recuerdo dimentiado

... es mucho más importante
que un beso

si inventar algo de
mí, yo no puedo darte
nada, ni quiero, pq eso
donde nada me pertenece no es
pero todo, de alguna manera, amor
se apropia de mí.

hoy soy un espejo en el que
me miro y lloro sin pena.

y para mí vale la pena, que me
condene este lugar.

quiero llenarme de bonito.

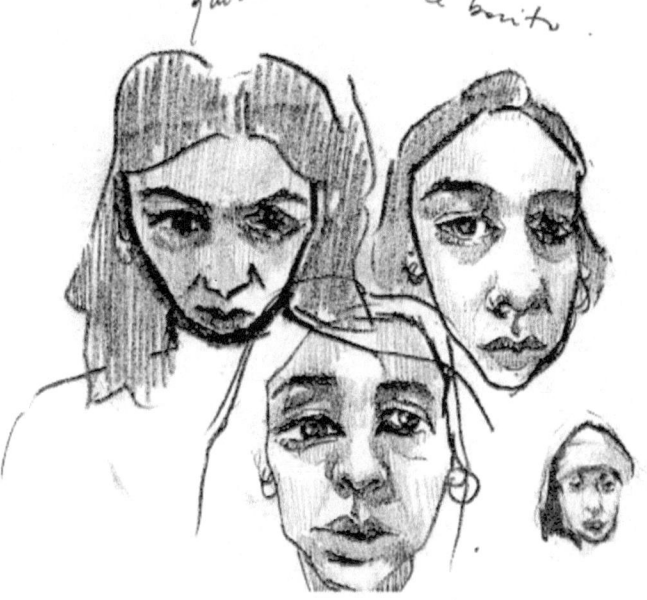

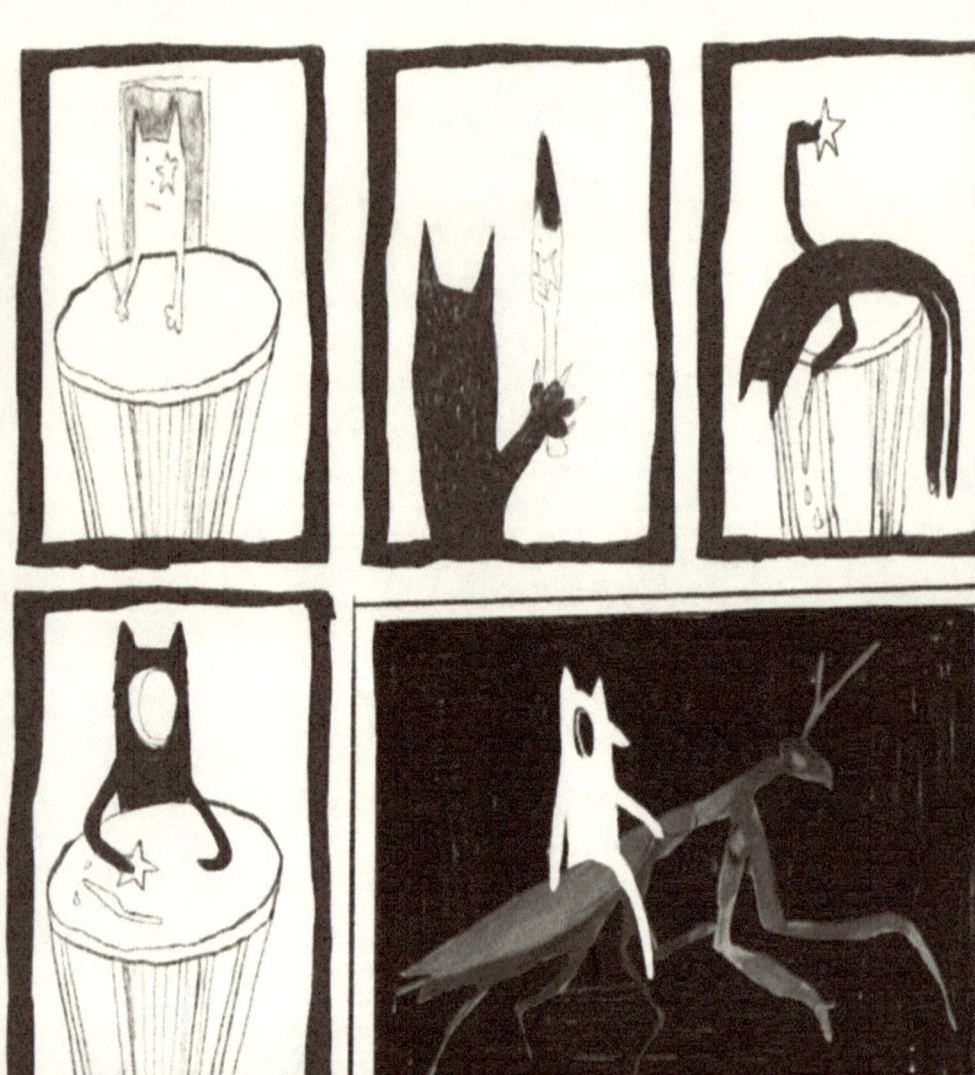

AT LAST, THE TIME HAS COME.
TEST OUR BRIGHTNESS.
I DIDN'T FEEL ANY HEAT AT ALL.
ALL MY LIFE I WAS SHELTED IN A
SMALL MOLECULE OF LIGHT.
THE TIME HAS COME, BE ABLE TO
SEE THE REALITY WITHOUT ANY
KIND OF LIGHT.
TRY TO KEEP THE MANTIS CLOSE.

THE HOUSE OF COBWEBS

COBWEBS HUGGING PEPPER

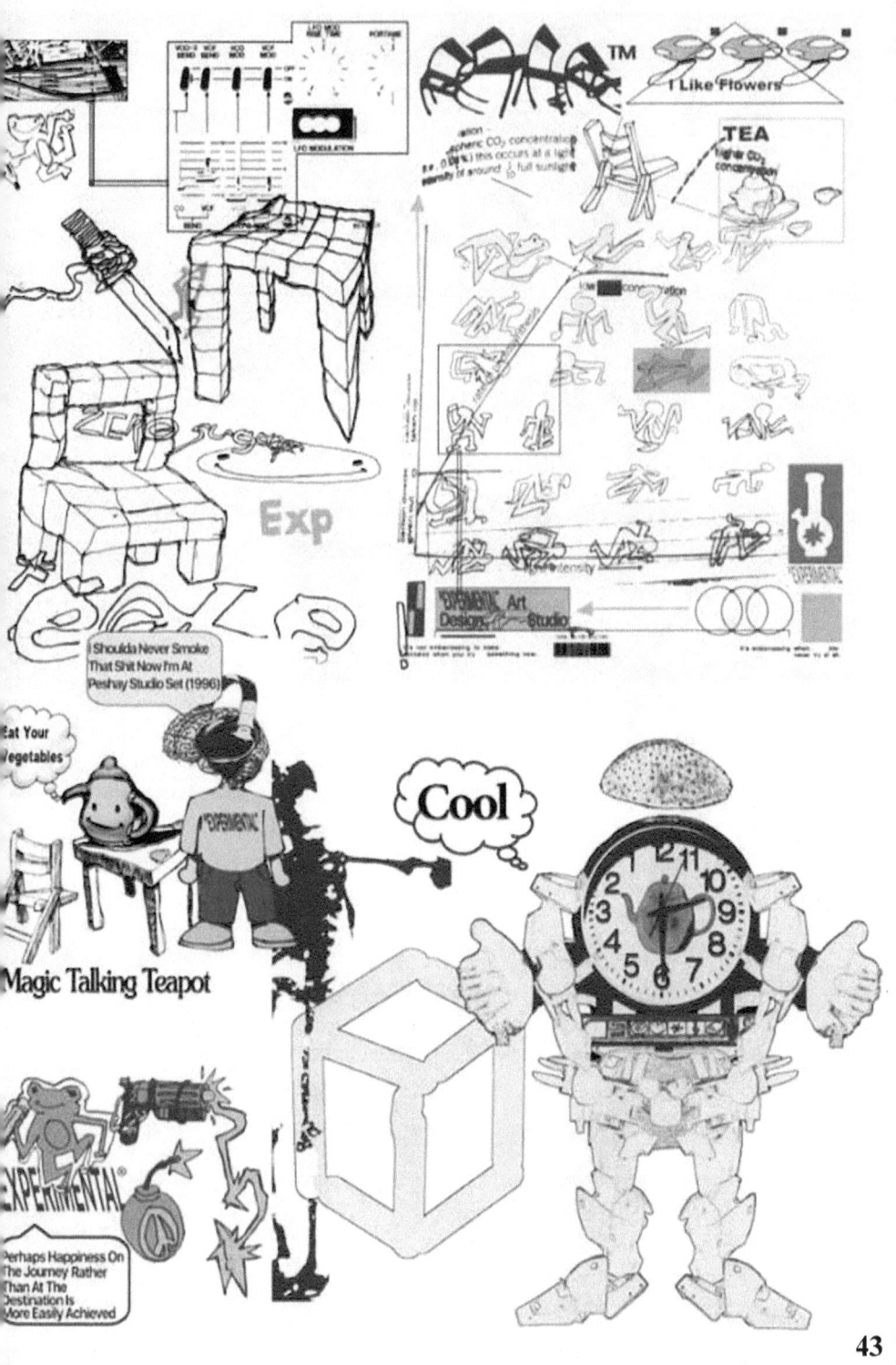

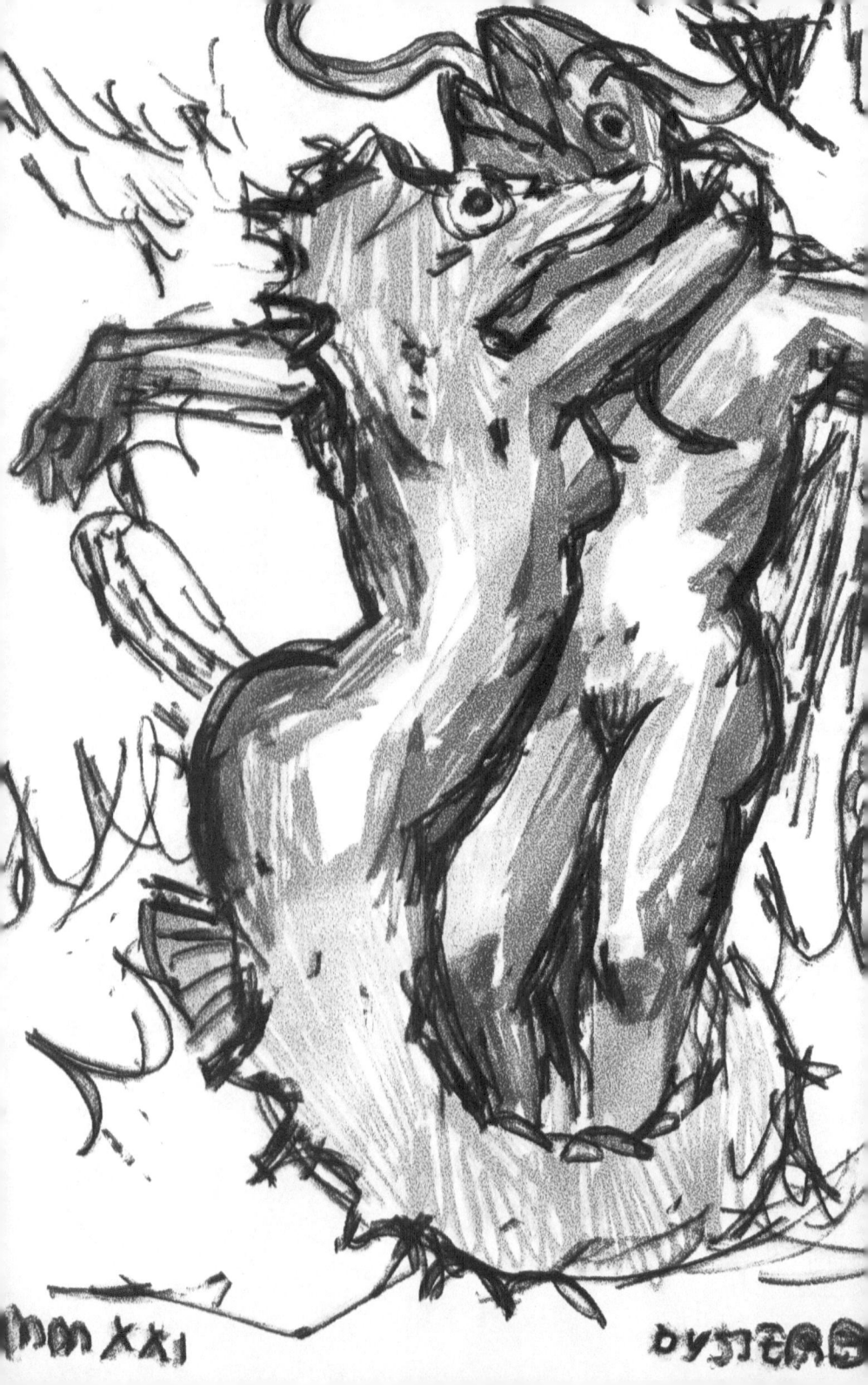

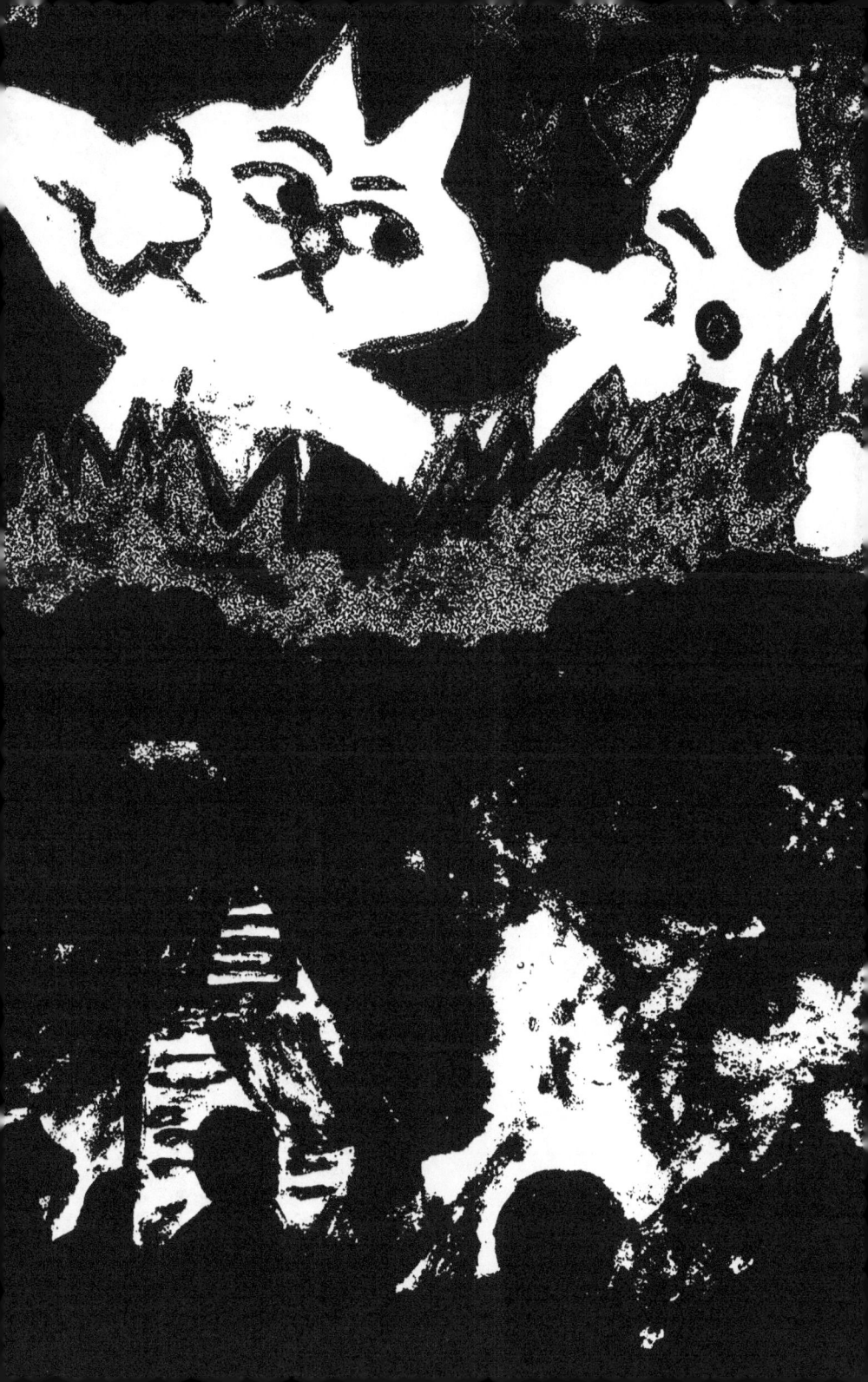

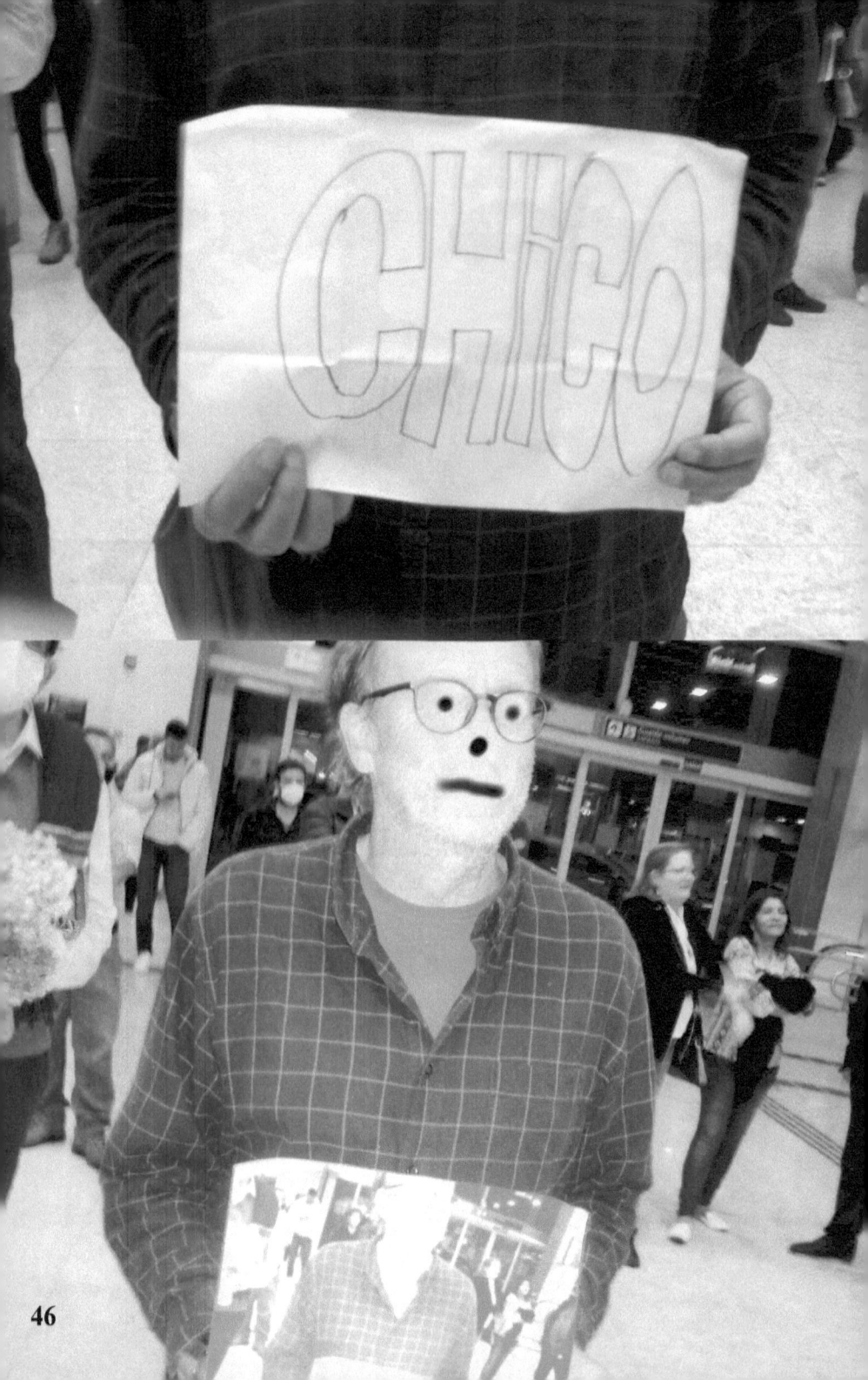

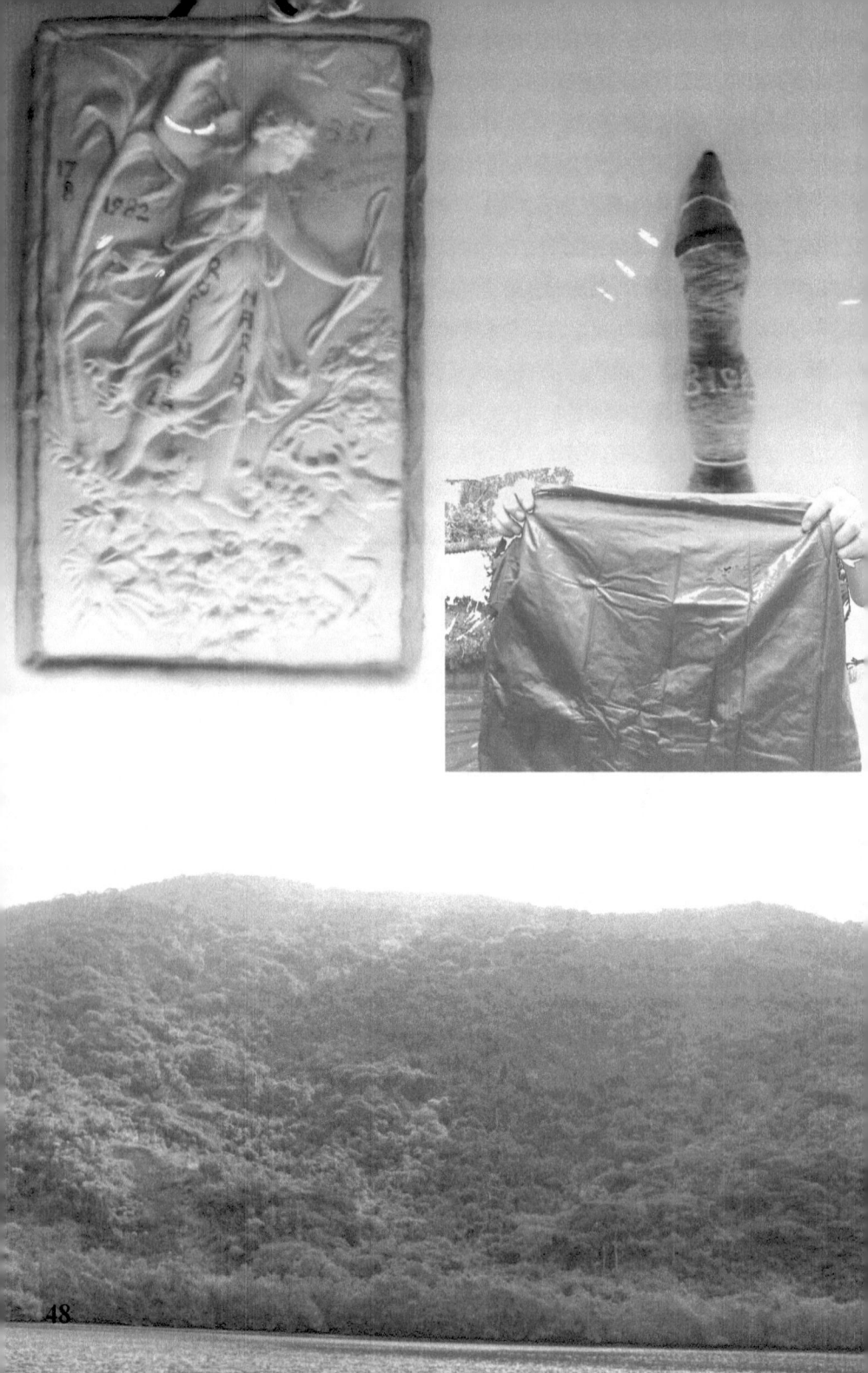

48

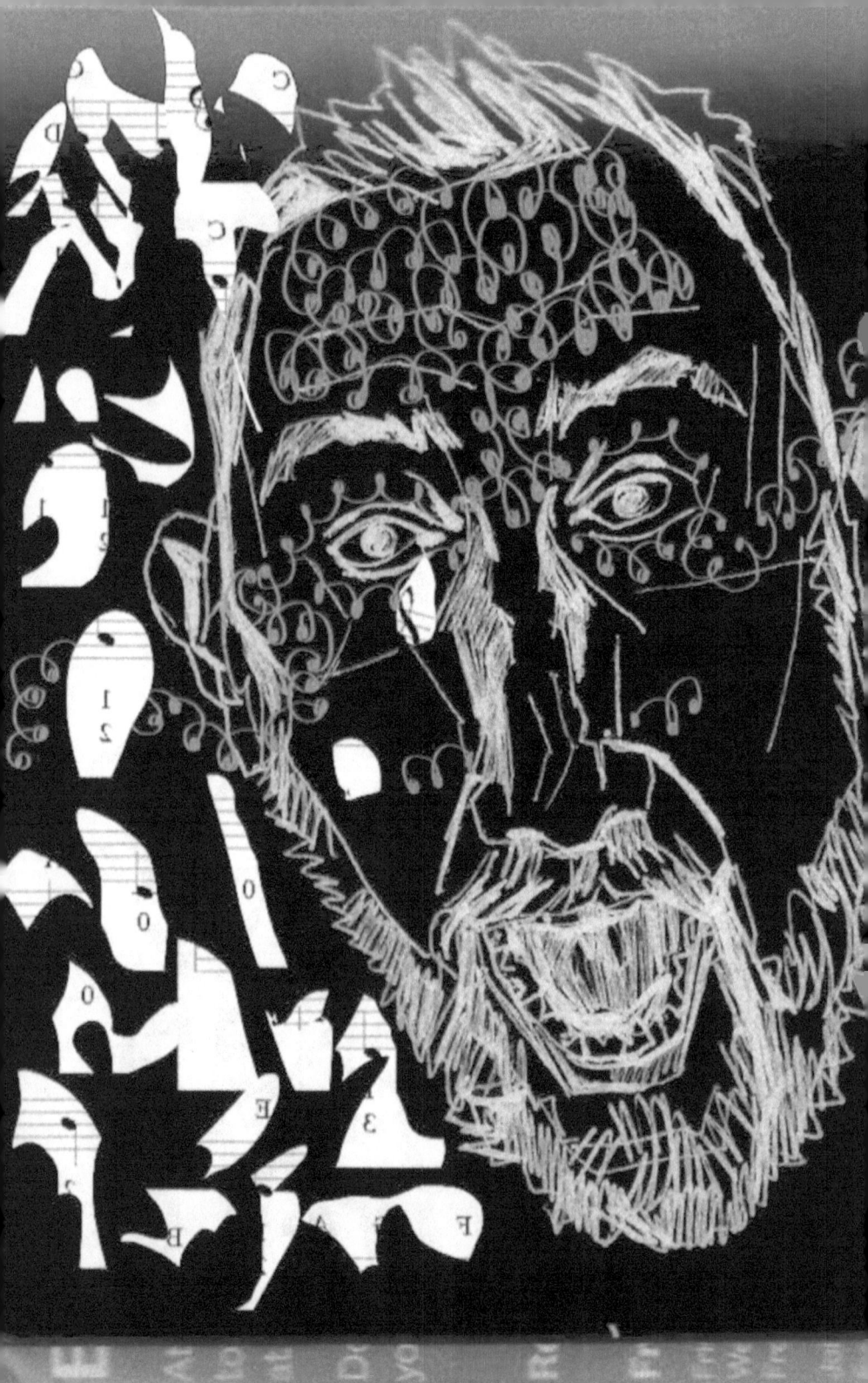

You really must stop looking at the early life/education section of Wikipedia.

THERE IS NO GAIN, IT ONLY CAUSES MISERY

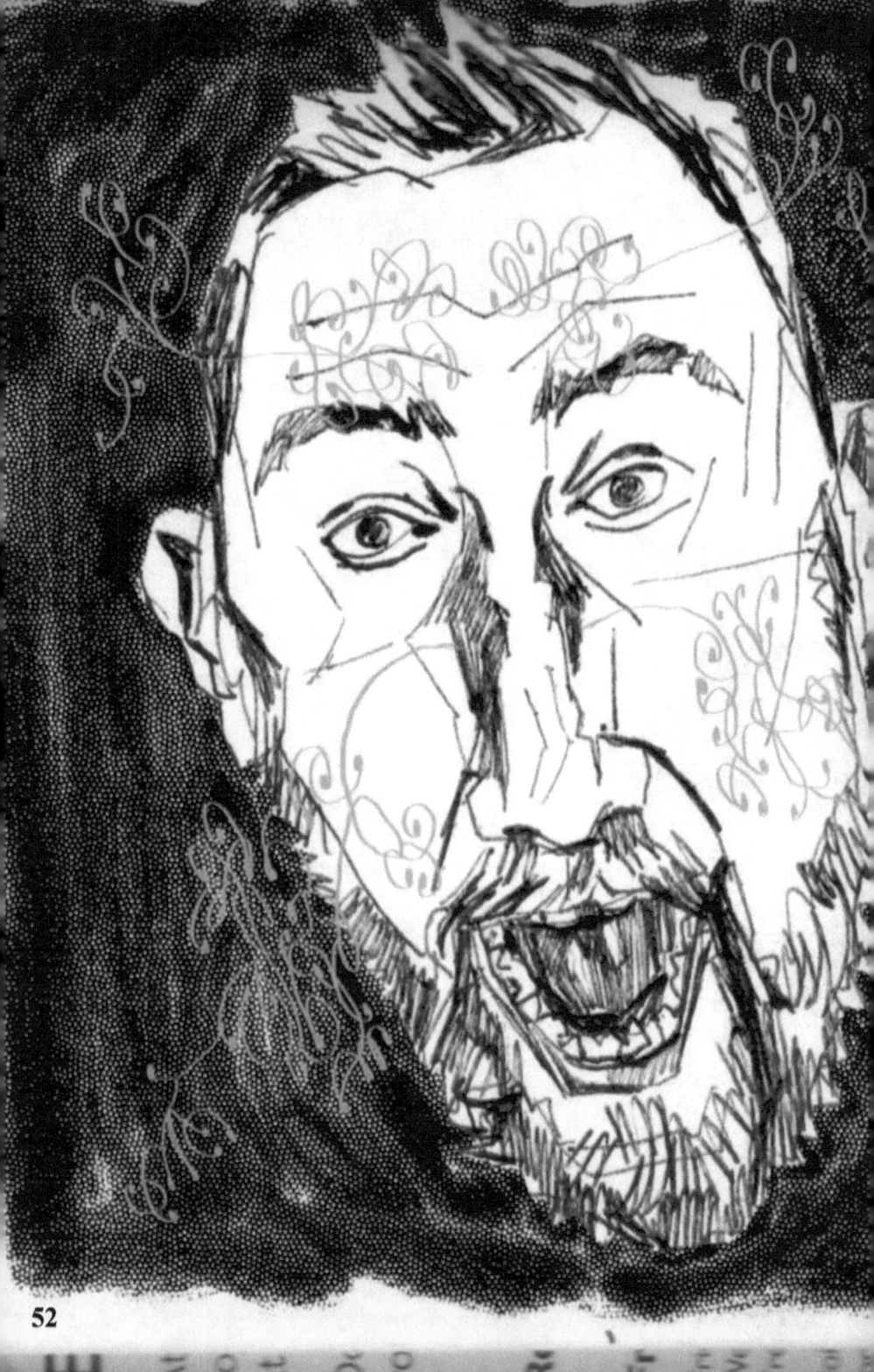

SKETCHBOOKS
SKETCHBOOKS
ARE ESSENTIAL.
SKETCHBOOKS
ARE ESSENTIAL.
USE YOUR
SKETCHBOOKS

you are flooding my thought worm
and my psychological eyes
and everything really
what is it that you want? because you remain silent with your omnipresence
my little red roots warmed by the thought of your canine teeth and awkward hugs

you won't ever die
even if you do die
a second you which i sometimes wish was the one you, is here, in the thought worm and in the red roots
and i hang on to the you that is made up
a stuffed rat to hold close when asleep
ceramic frogs and polyethylene chickens
i want to feel like i know you
even if you've let me see there's a wall, not to be climbed or
and i think i've gone through and am standing on the other side of silence and incommunication,
what a fool believes
pathetic and lovesick teenager
as if writing would make them realise
i'm here and i've been here for some time already maybe
they're there too, there being here
but here and there being two bus stops in the same two-way street and the synchronised and uninterrupted transit of cars and yellow trucks doesn't let me see you
i don't know if you can see me

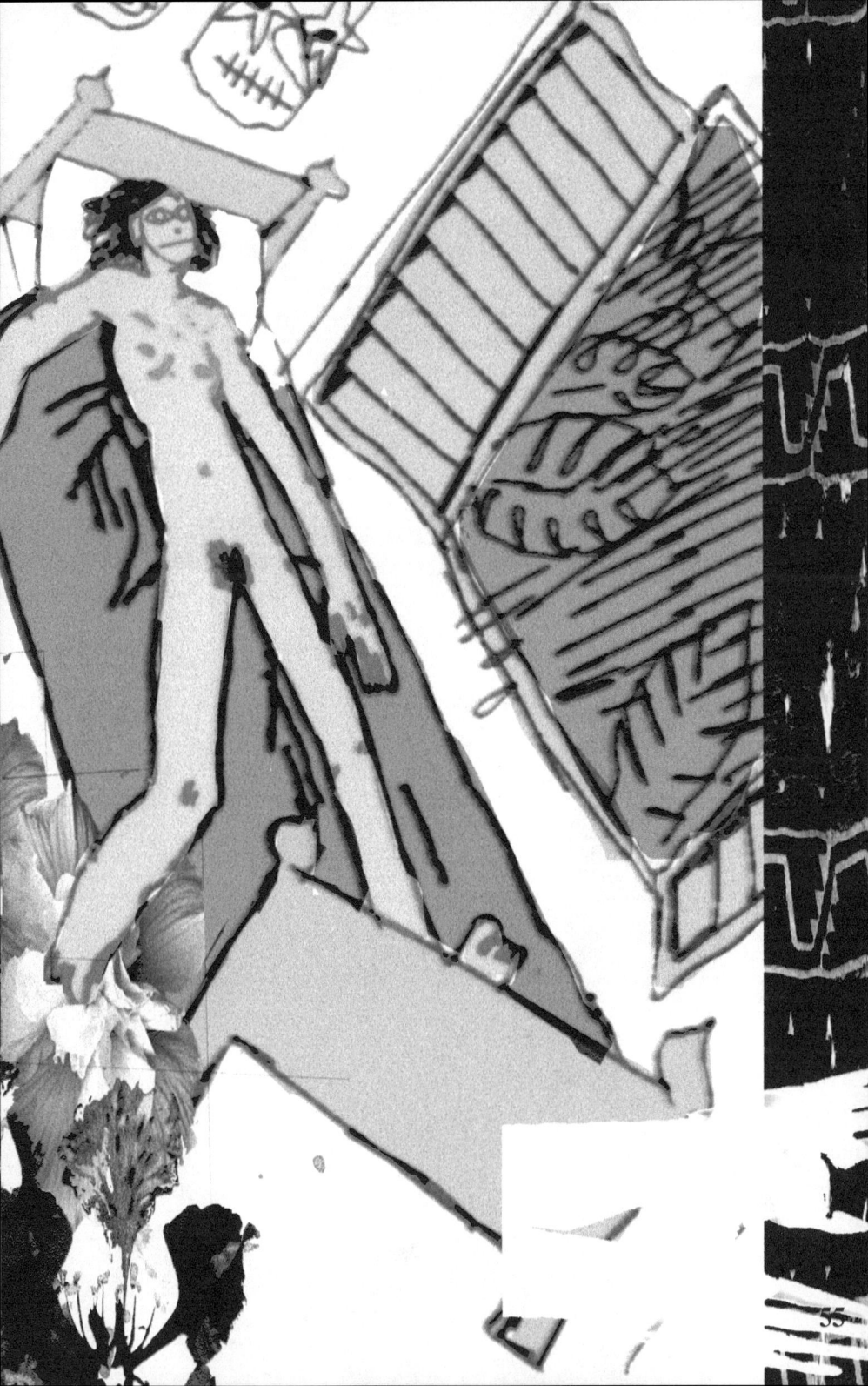

UNTITLED VERSE ABOUT ROWS AND ROWS OF GLASS VIALS,

I wished I could become a see-through thing.
Diaphonization is the usage of chemicals and dye on a
specimen to sort of jellify it; the bones
and cartilage become not only see through,
But tinted with blushing pinks, blues and
yellows. The result is something half-organic
that appears to be completely watercolor.
If you put two transparent objects on top of each other–
this happens when positioning diaphonized specimens,
arms
rise, fingers curl as if to protect the face from impact; the
specimen
might assume a fetal-like position –
the details of the limbs become obscured.
The brilliant blue that traces the joints of individual fingers
become mere lines
with peach spaces below them, between them, inside of
them.
I wished I could become a see-through thing, and now I
am only wondering
what I am standing behind

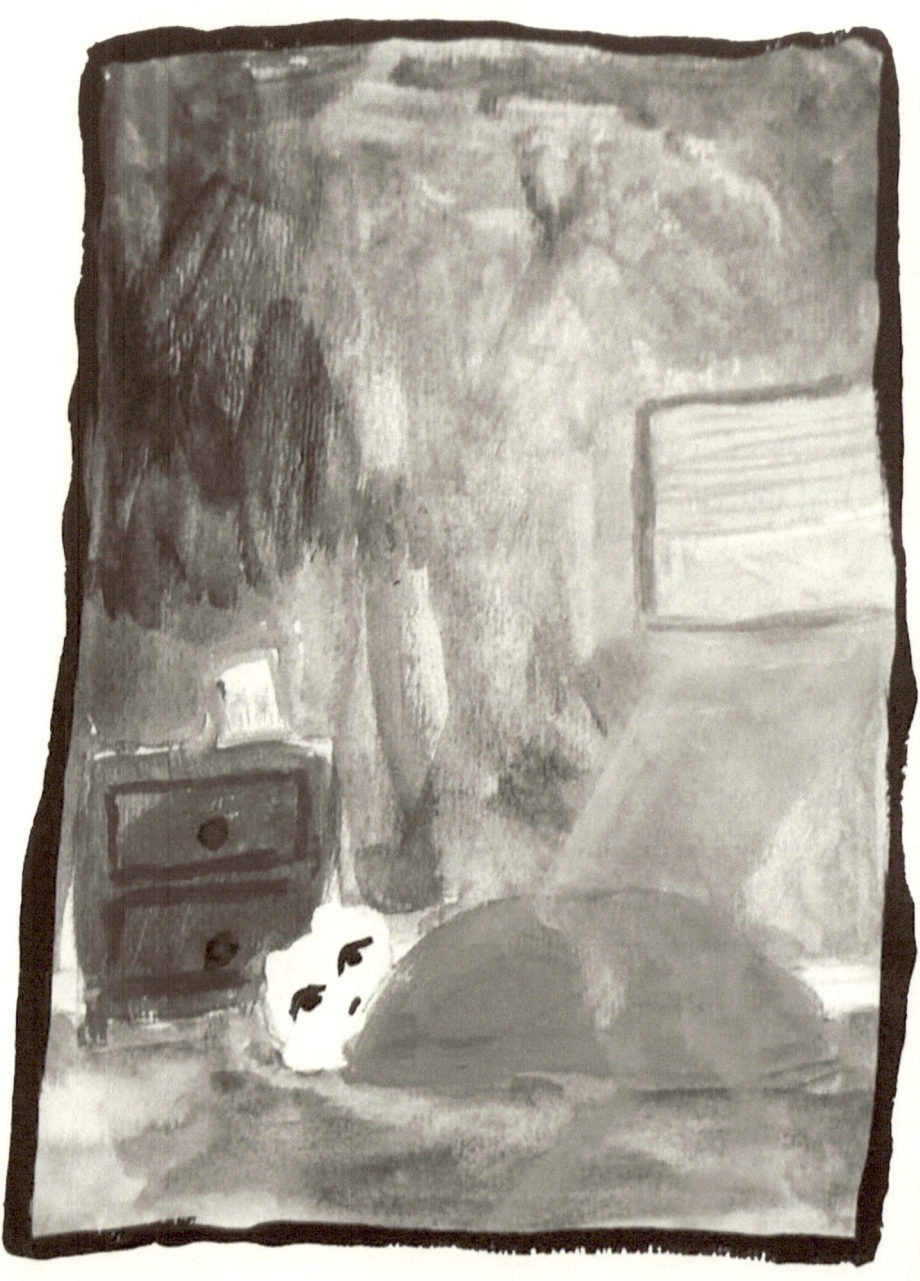

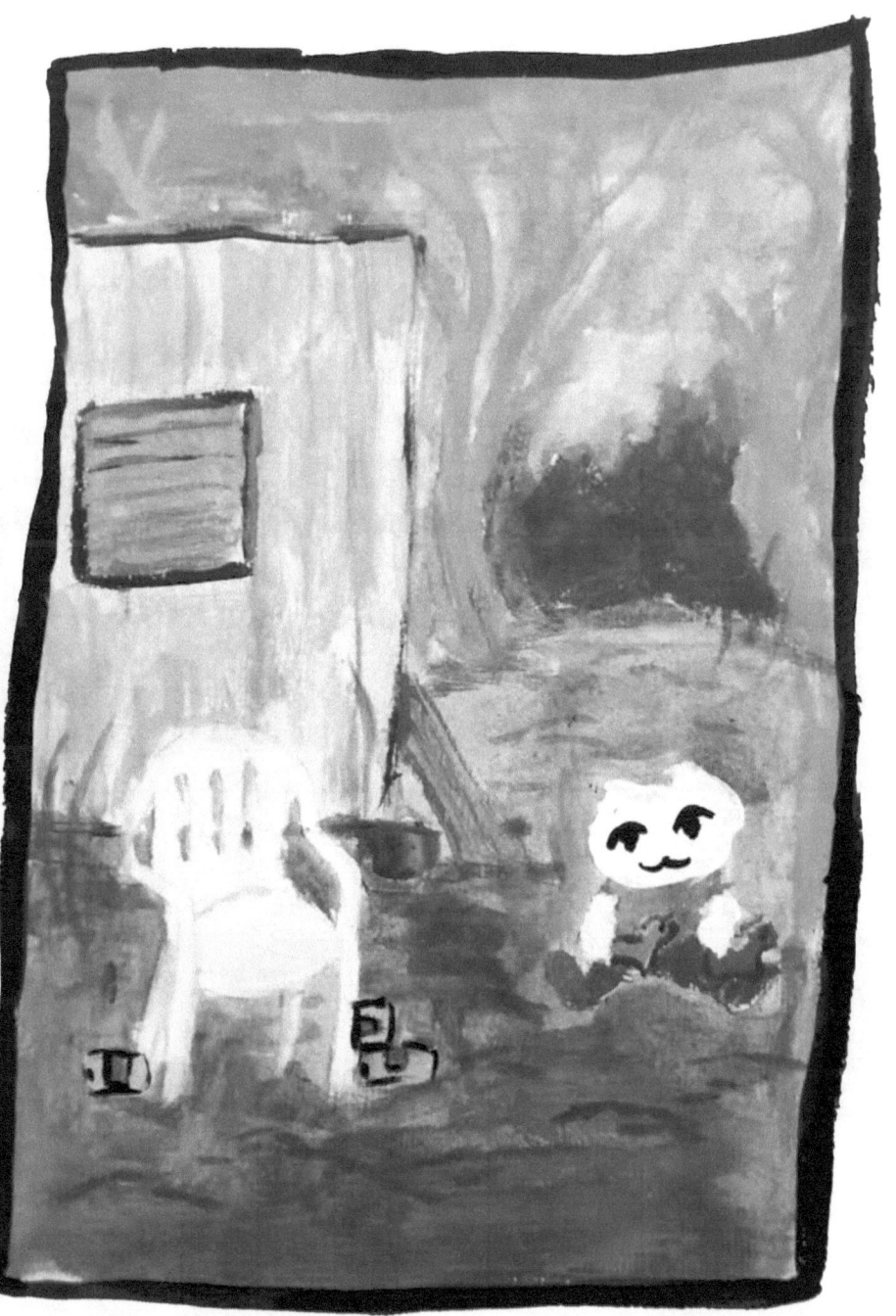

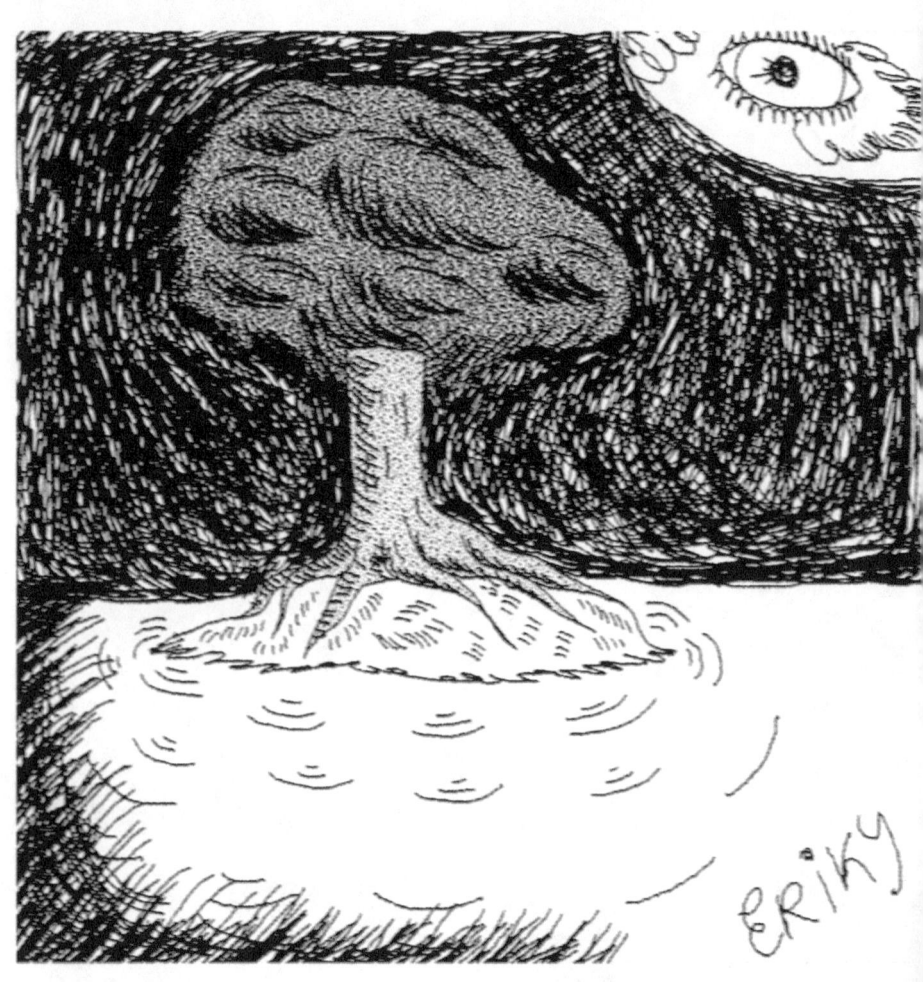

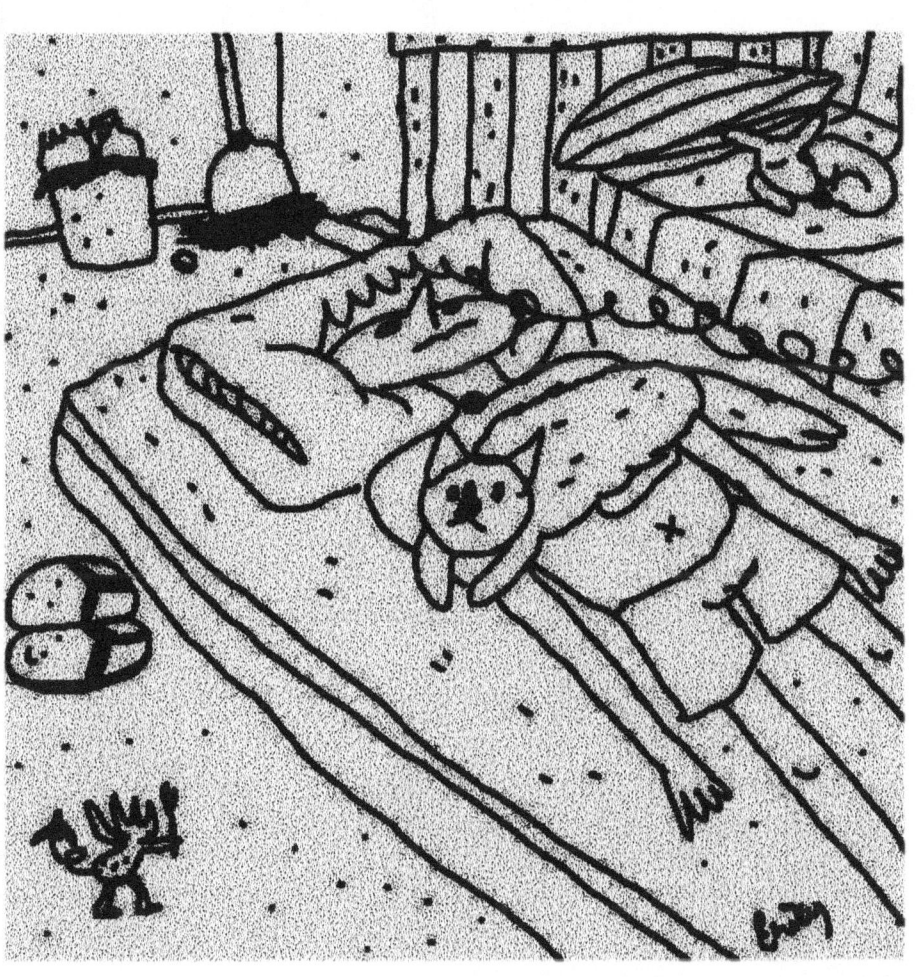

intertwined
fingers of warmth,
of smirk, of being
so close i can feel
your lungs and
your heart and
your thoughts

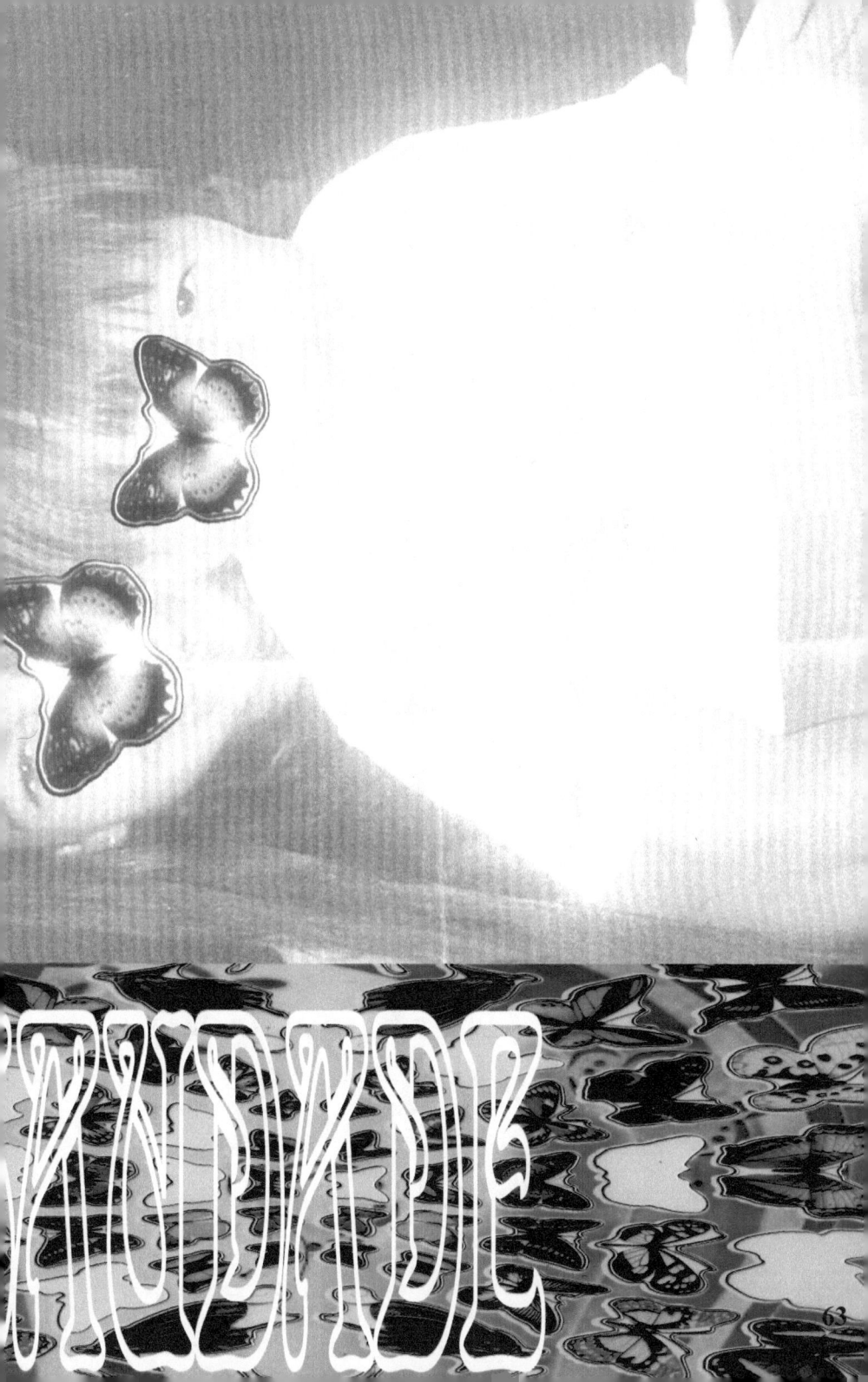

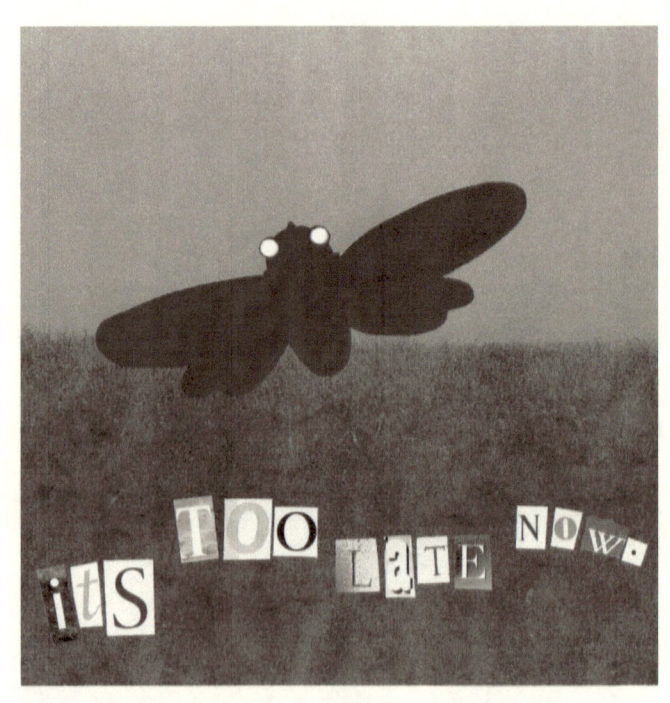

"It's too late now"

some (ii) spreads by Lucie Orozco

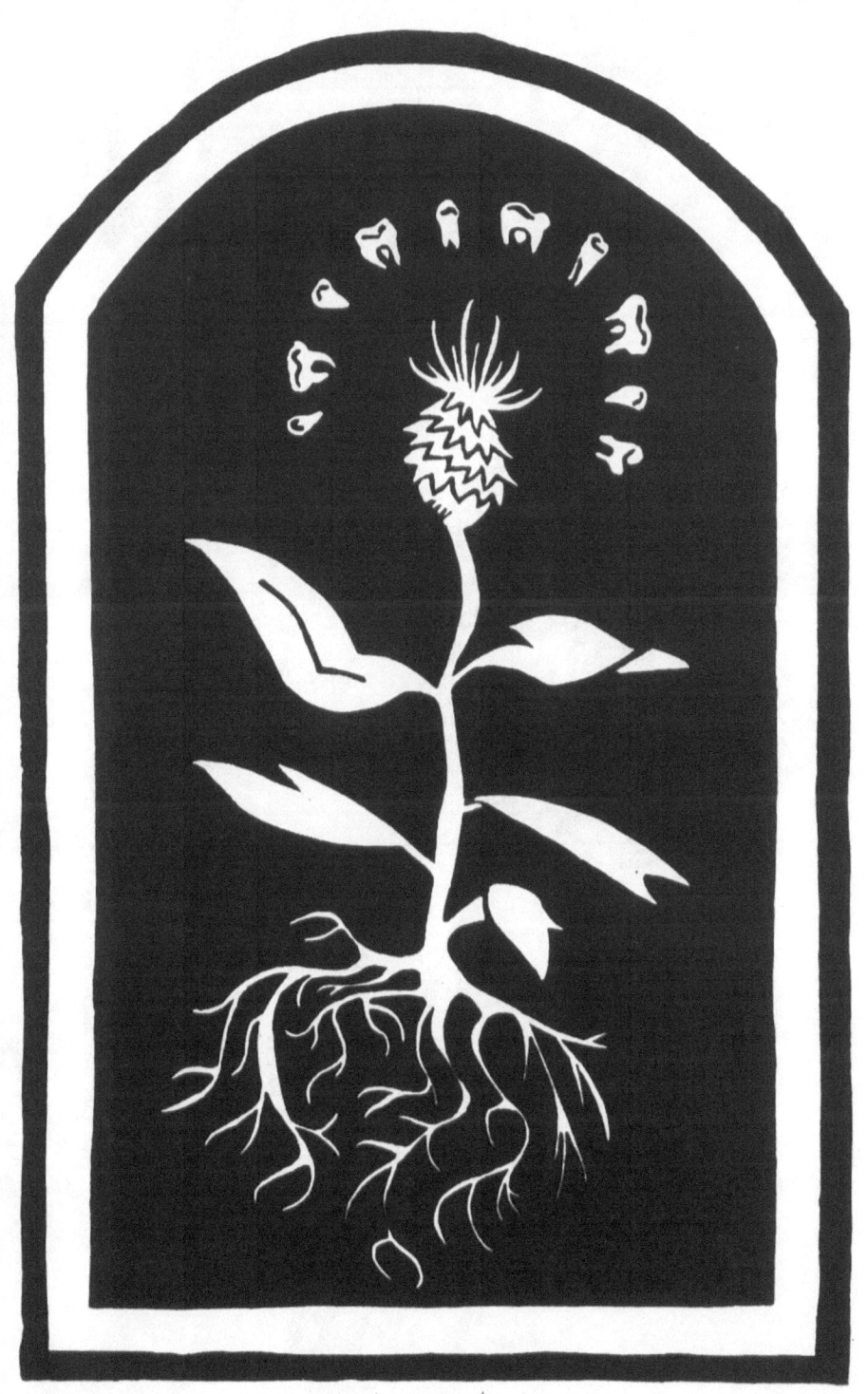

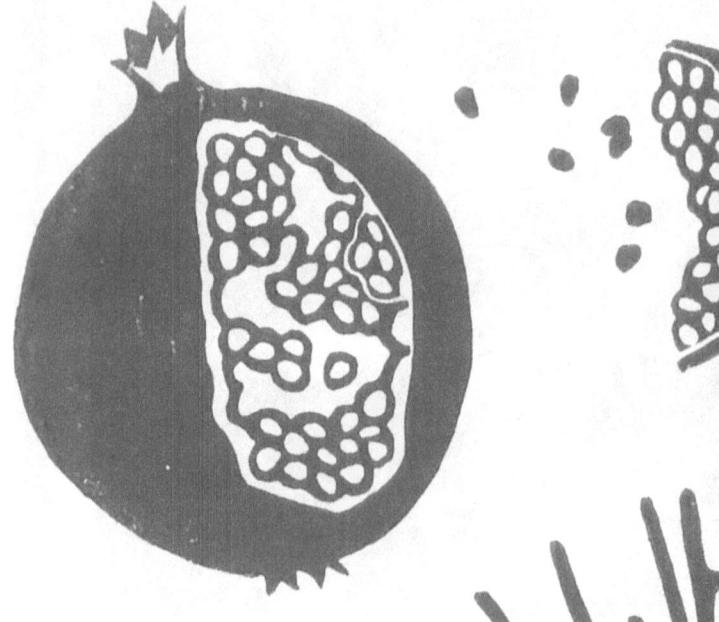

'Pretending I Know What a Pomegranate Looks Like' L.O.

67

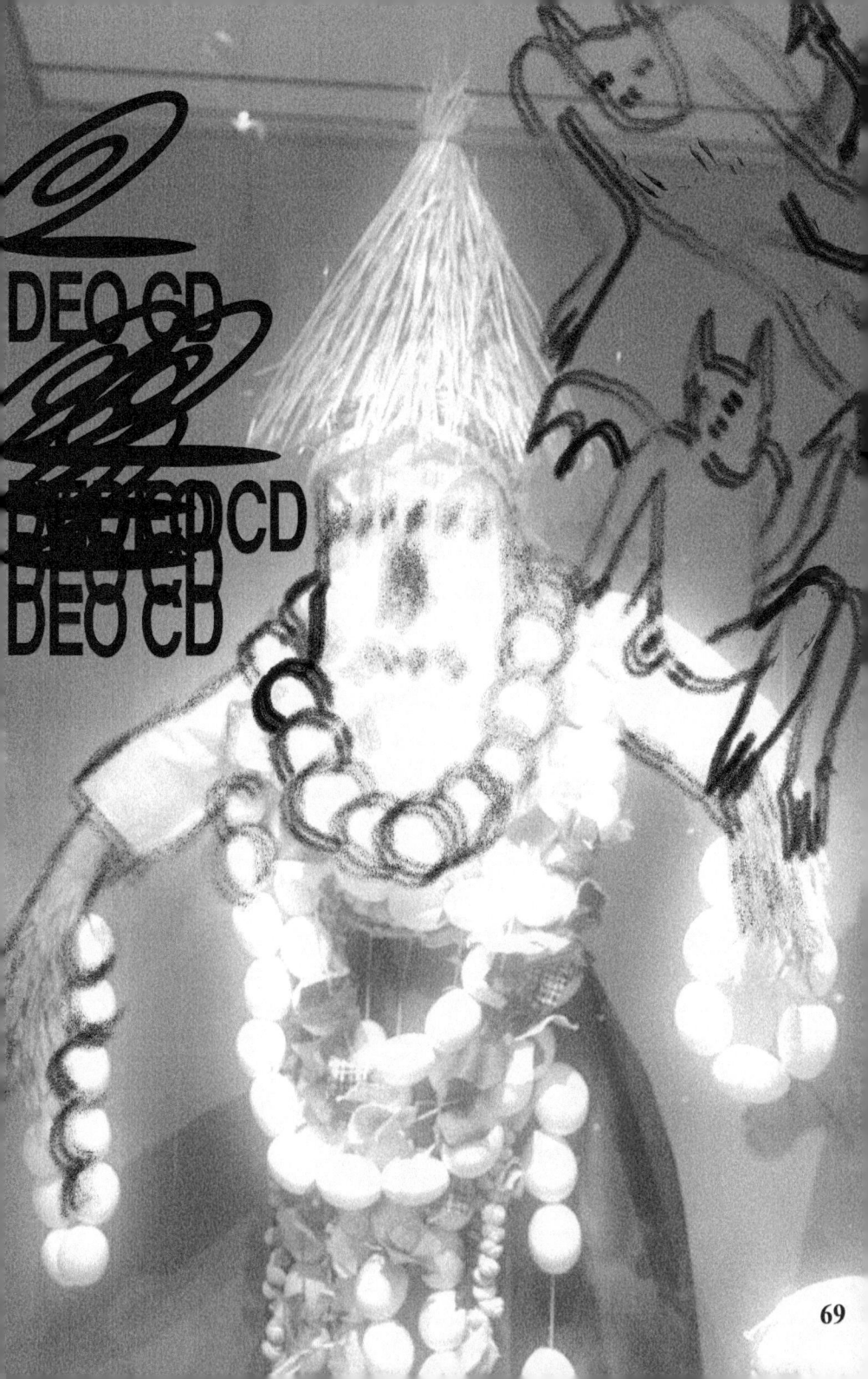

No windows, no doors

Locked up in four walls,
No windows, no doors,
He longs for a garden
And a bright red flower.

Insomniac nights, that deafening silence of the stones,
And creaking of his weakened bones,
Deranged his mind and fogged his thoughts
Until his breath was seldom knots.

Soon death became his biggest wish
Until one day the floors would split and swish.
A gate, a hole, a dark, dark pit,
It was so small he barely fit.

Weeks and days he passed in there
Trying to exit the pit any where.
It was pitch black.
Fifty wrong turns. He never came back.

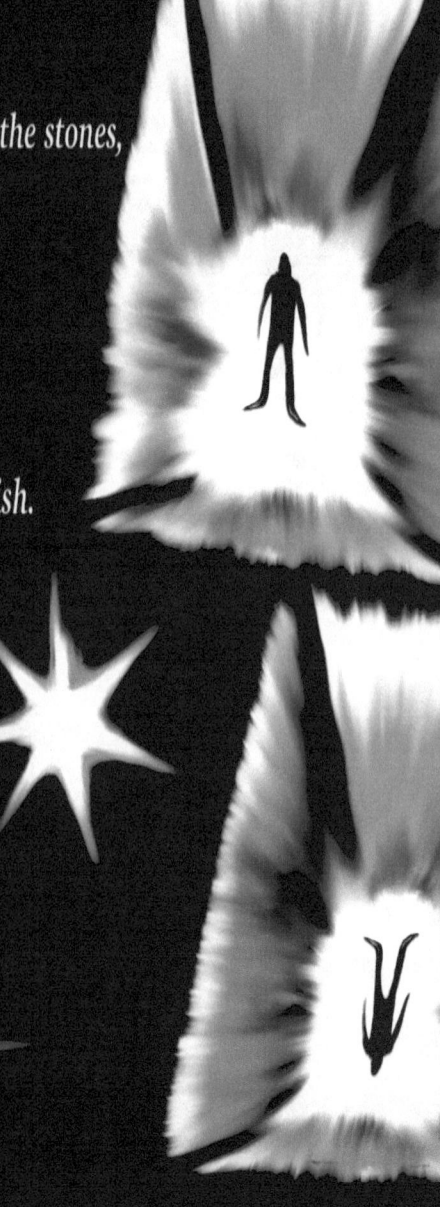

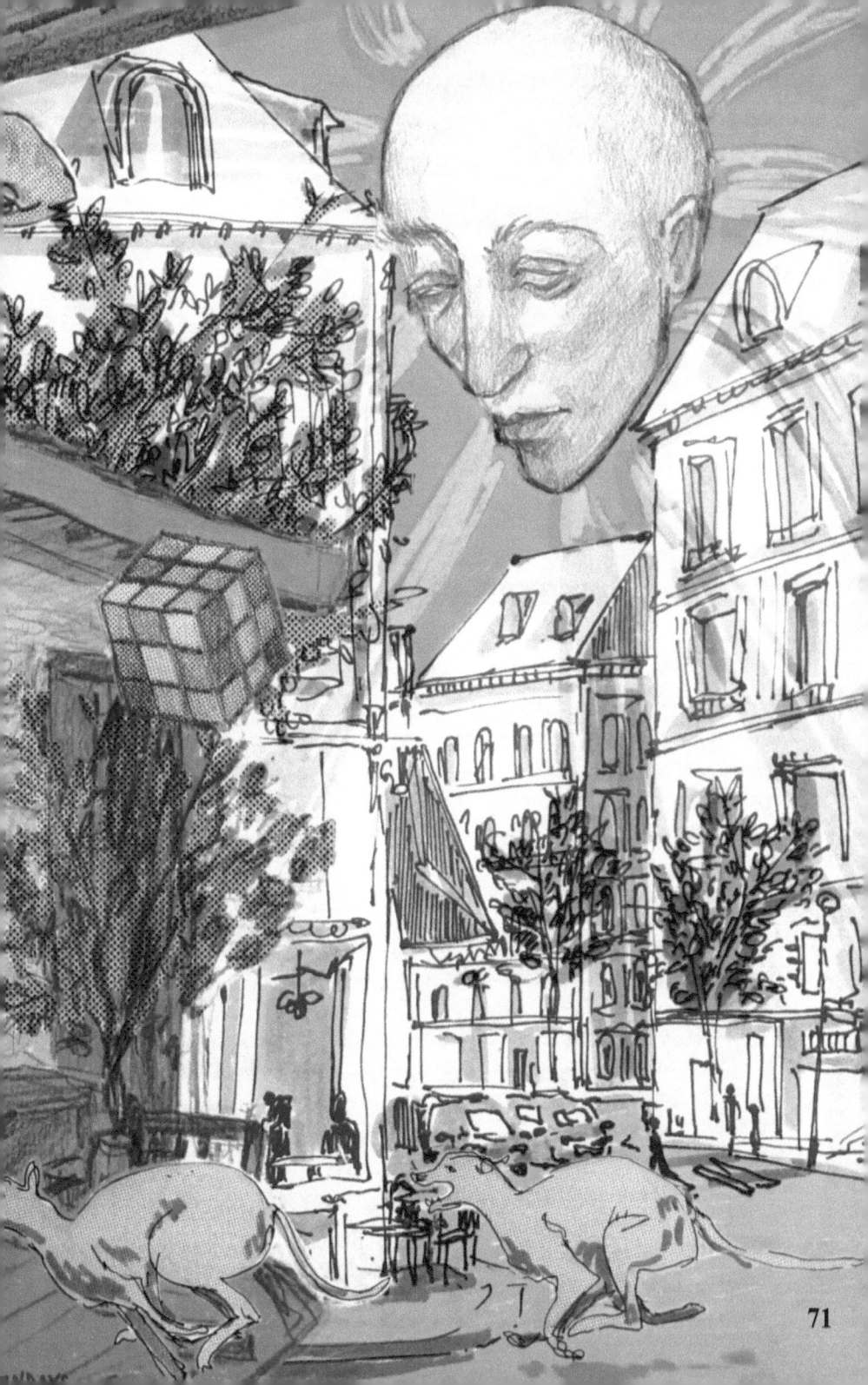

The skies, they were ashen and sober;
the leaves, they were crisped and sere —
The leaves, they were withering and sere.
It was night in the lonesome October
of my most immemorial year;
it was hard by the dim lake of Auber,
in the misty mid region of Weir —
It was down by the dank tarn of Auber,
in the ghoul-haunted woodland of Weir.

Then, my heart grew ashen and sober
As the leaves that were crisped and sere —
As the leaves that were withering and sere,
And I cried — "It was surely October
on this very night of last year
that I journeyed — I journeyed down here —
That I brought a dread burden down here —
on this night of all nights in the year,
oh, what demon has tempted me here?
well, I know, now, this dim lake of Auber —
This misty mid region of Weir —
Well, I know, now, this dank tarn of Auber —
In the ghoul-haunted woodland of Weir."

Ulalume

The skies, they were ashen and sober;
The leaves, they were crisped and sere–
The leaves, they were withering and sere;
It was night in the lonesome October
Of my most immemorial year;
It was hard by the dim lake of Auber,
In the misty mid region of Weir–
It was down by the dank tarn of Auber,
In the ghoul-haunted woodland of Weir.

Then my heart grew ashen and sober
As the leaves that were crisped and sere–
As the leaves that were withering and sere,
And I cried – "It was surely October
On this very night of last year
That I journeyed– I journeyed down here–
That I brought a dread burden down here–
On this night of all nights in the year,
Oh, what demon has tempted me here?
Well, I know, now, this dim lake of Auber–
This misty mid region of Weir–
Well, I know, now, this dank tarn of Auber–
In the ghost-haunted woodland of Weir."

– Edgar Allan Poe

Confession of a dog, chasing its tail

I often ask myself:
Why are you there?
Why can't I ever reach you?
What will I do if I ever can?

You, who always come from nowhere,
the one I always catch
in the corner of my eye.
The one and only, ever present,
barely even noticeable –
you.

Aleksandar Gabrovski

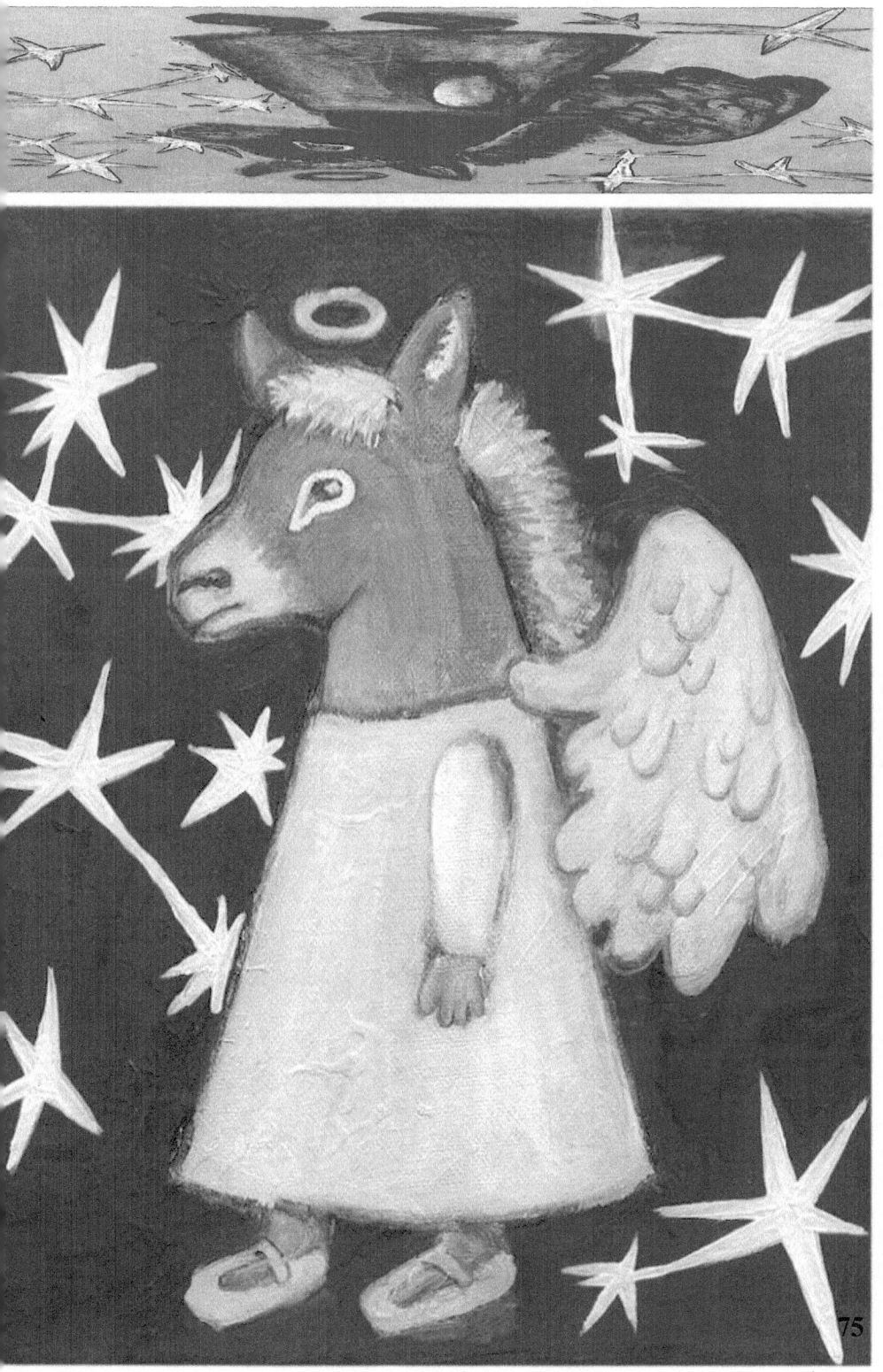

179375298795827599
642572637w1658153
76716571683715768
76175781671671695
63958137583771597
15754769672486748
67296487426679762
48672948676866786
87687687687687687

77

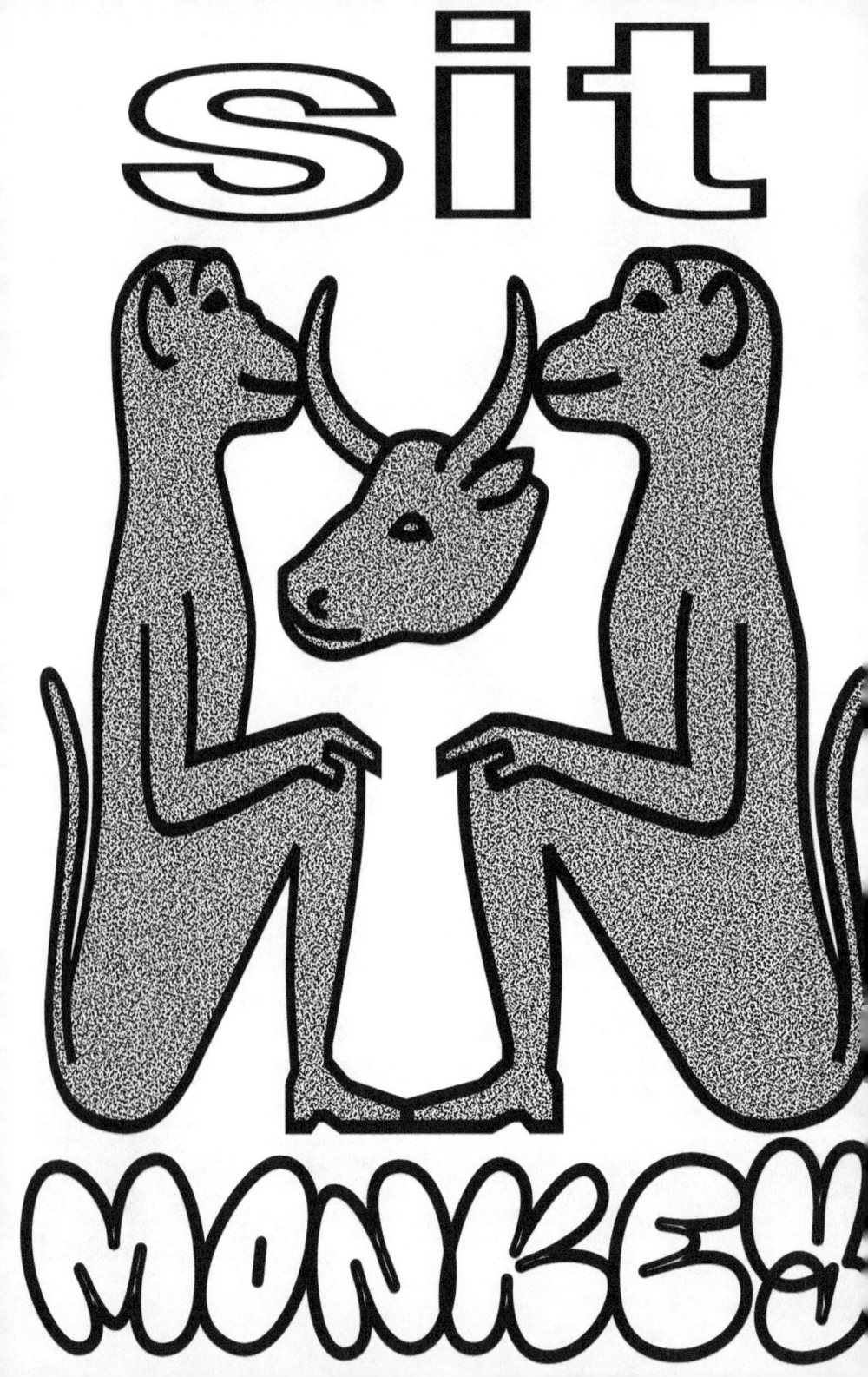

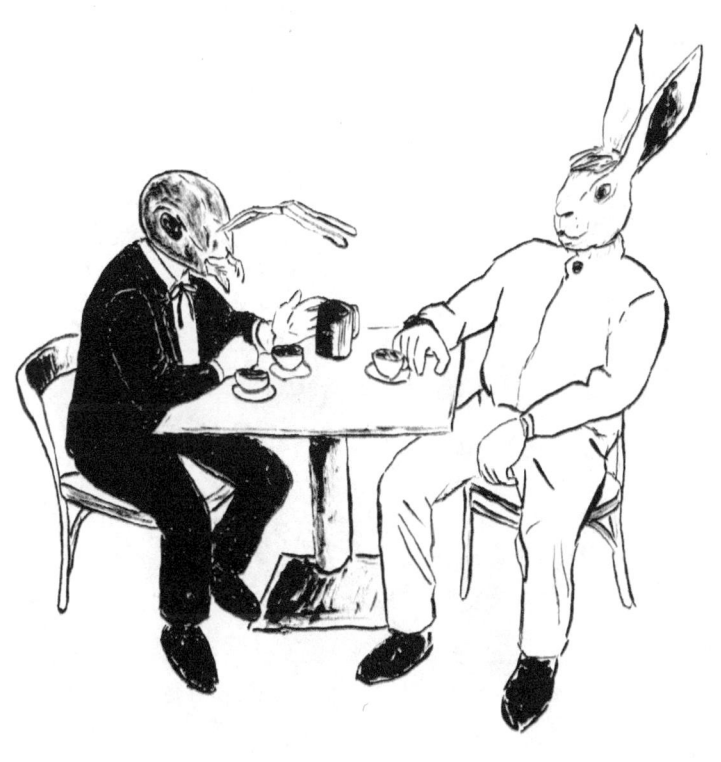

sweet hymenopters

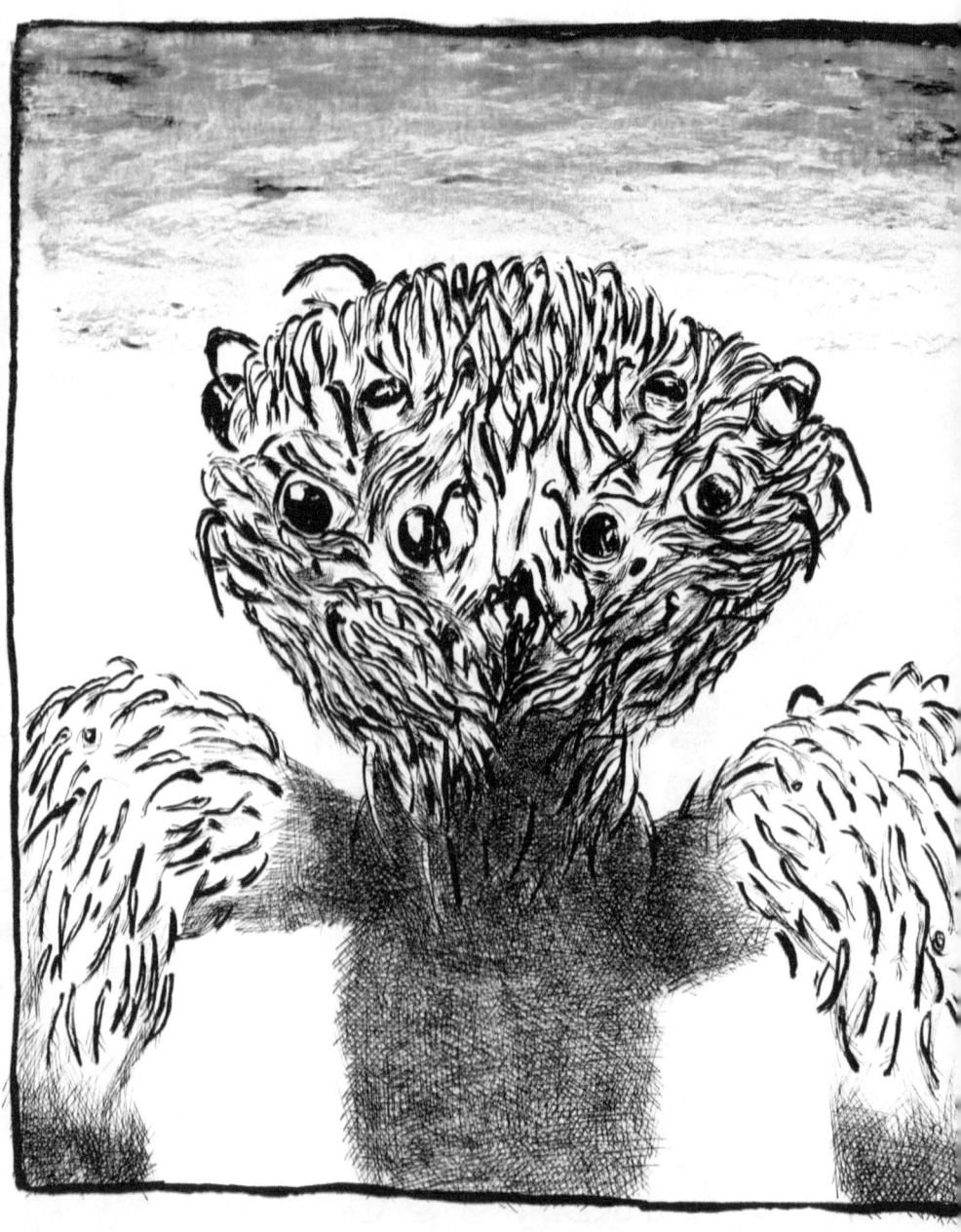

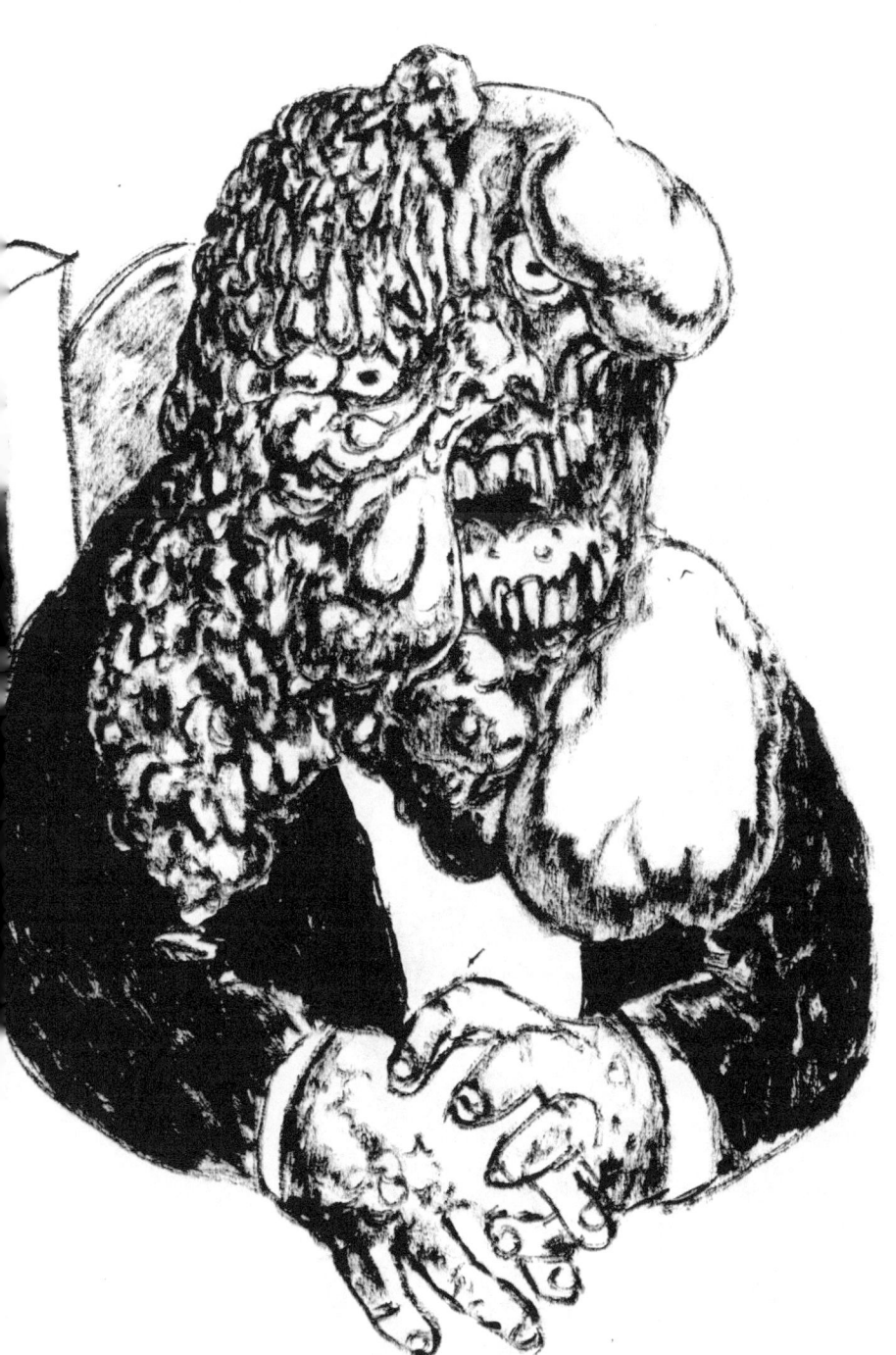

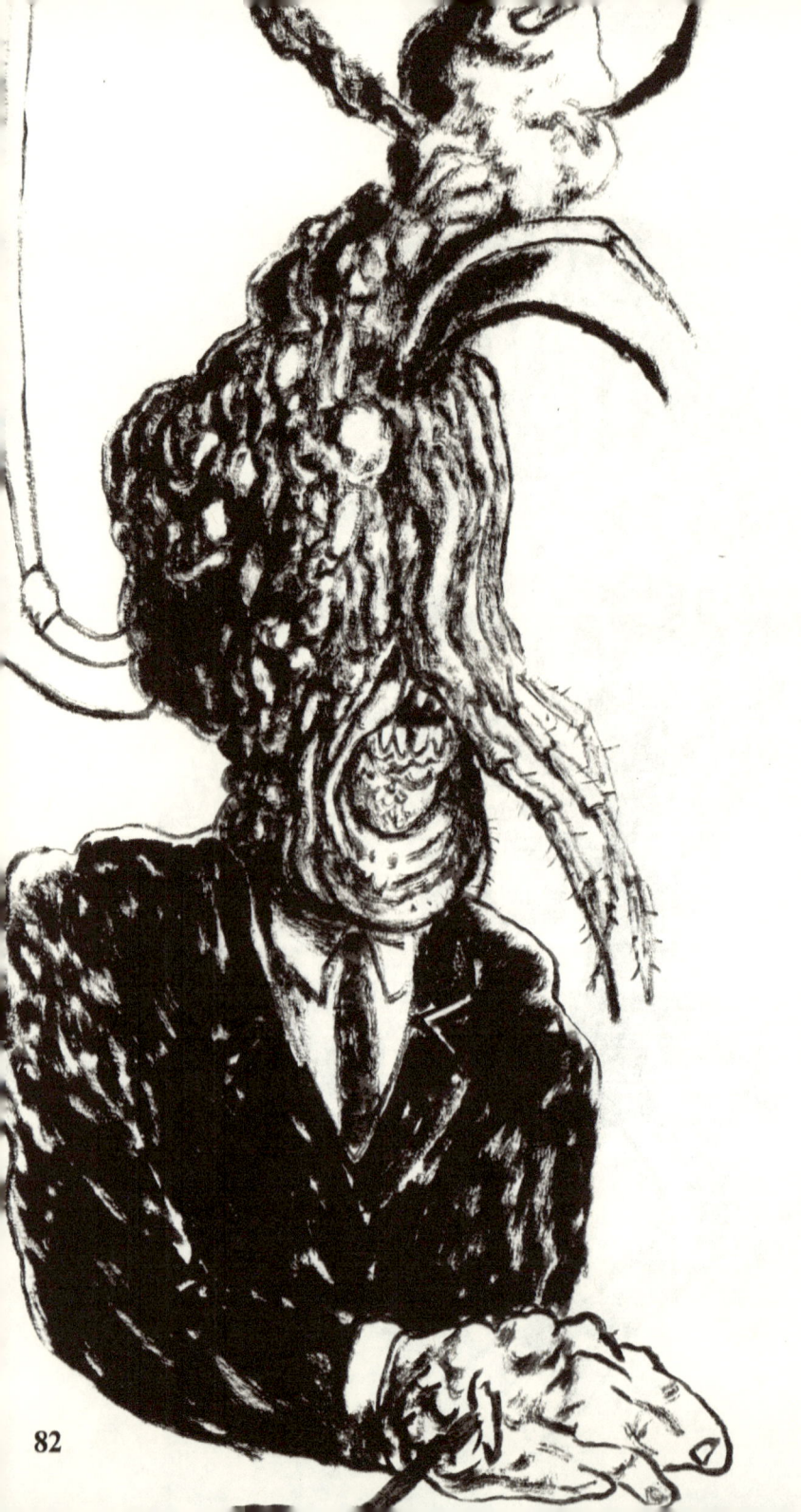

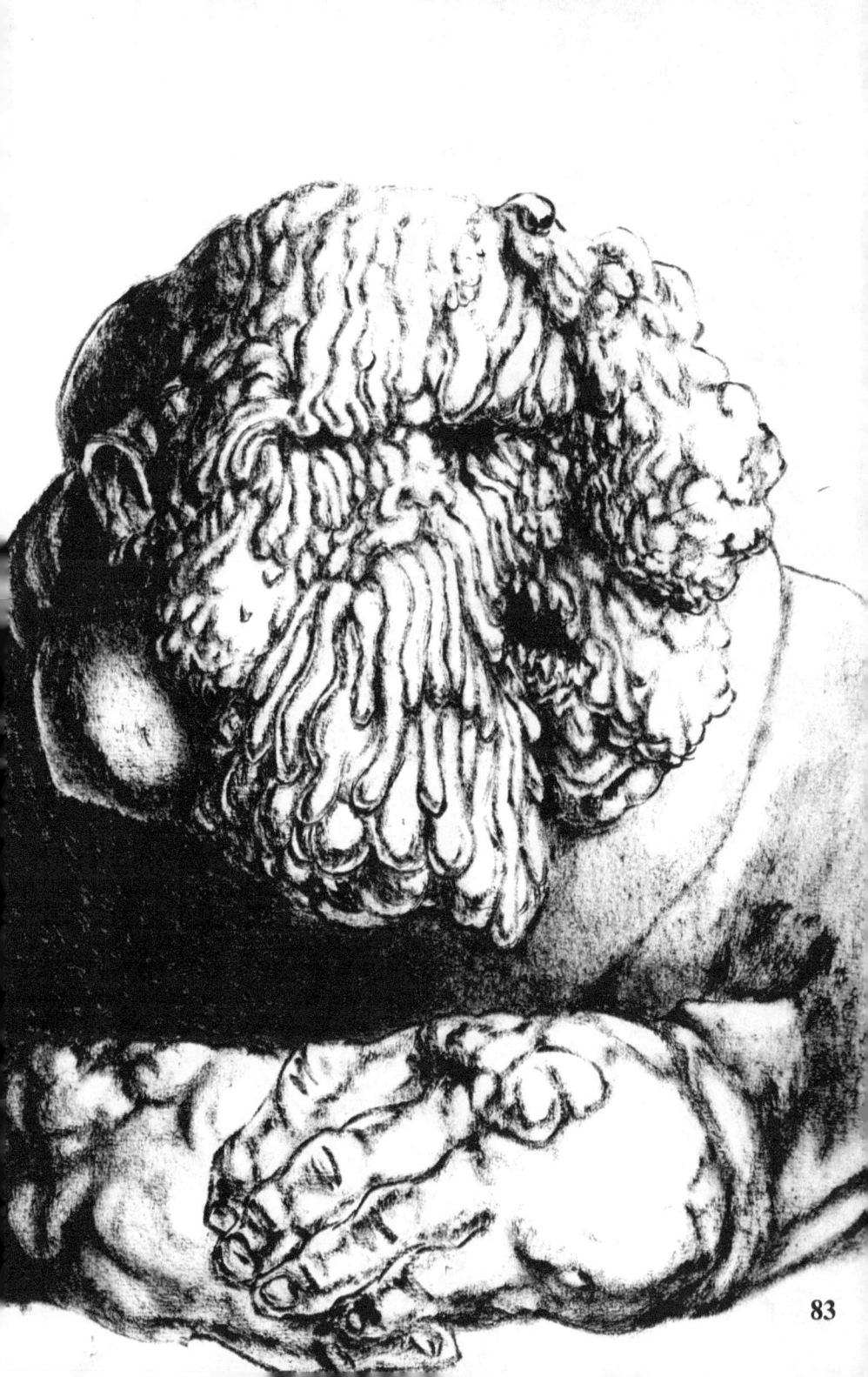

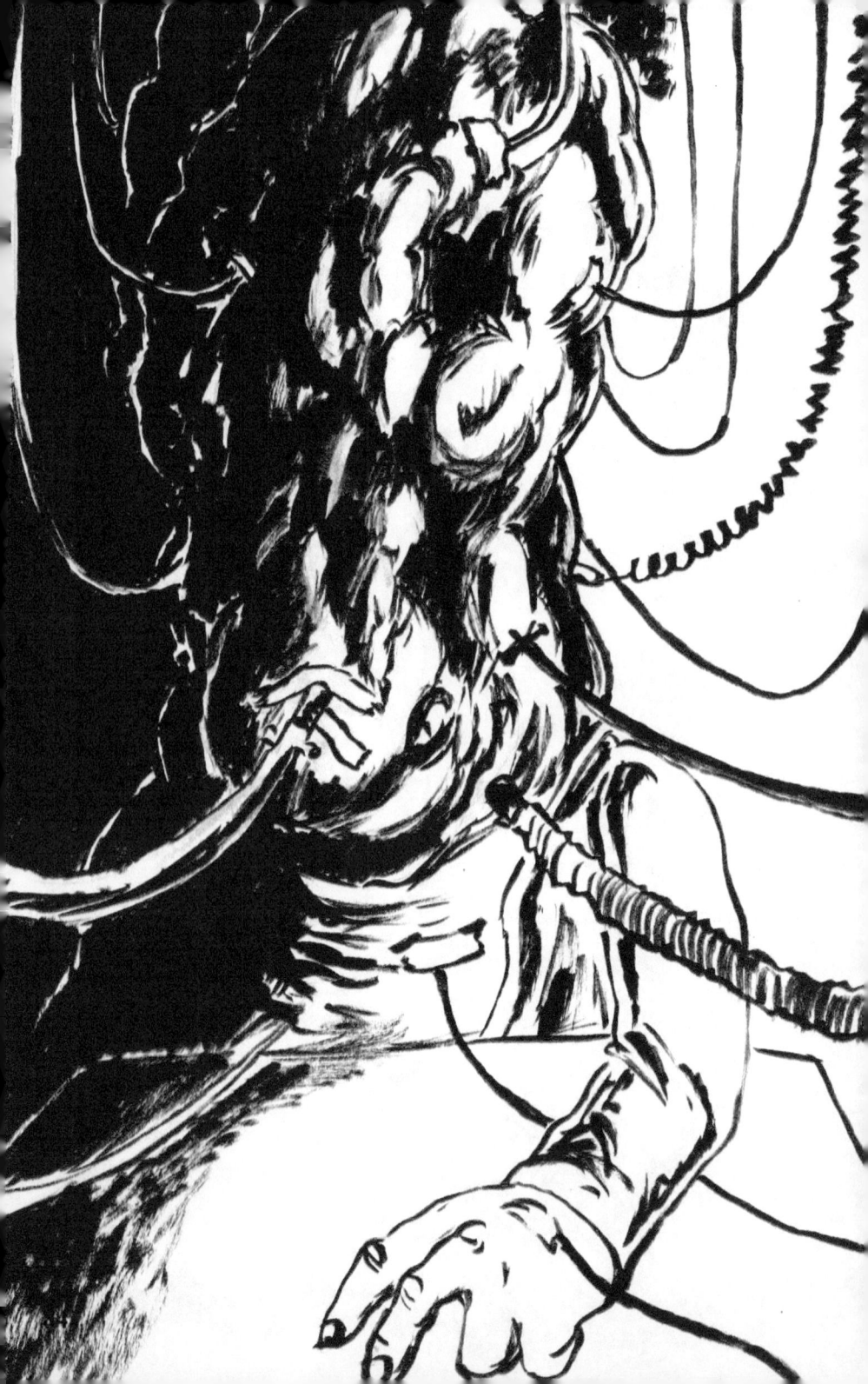

CONNECT THE DOTS TO COMPLETE THIS PICTURE OF A MELON

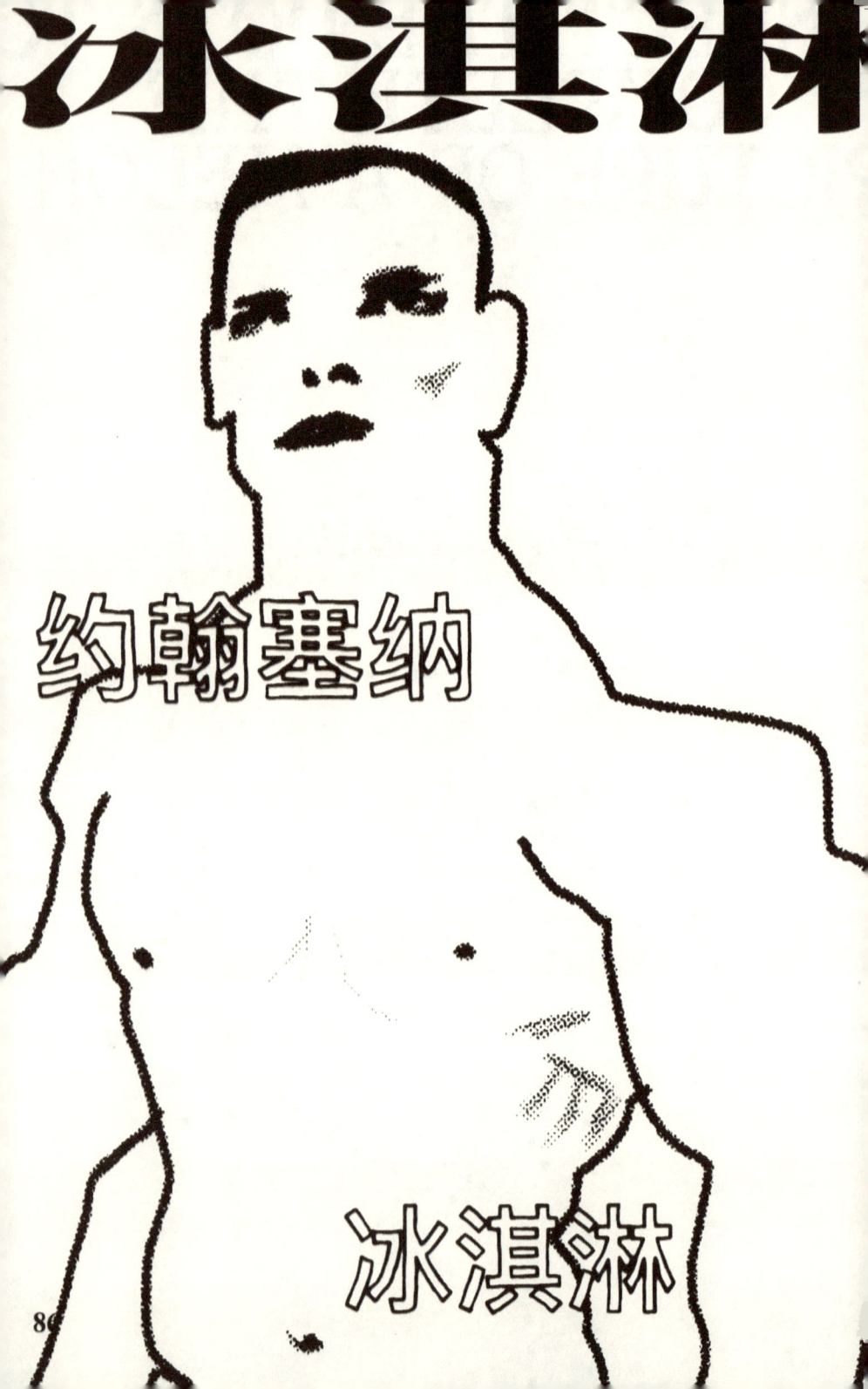

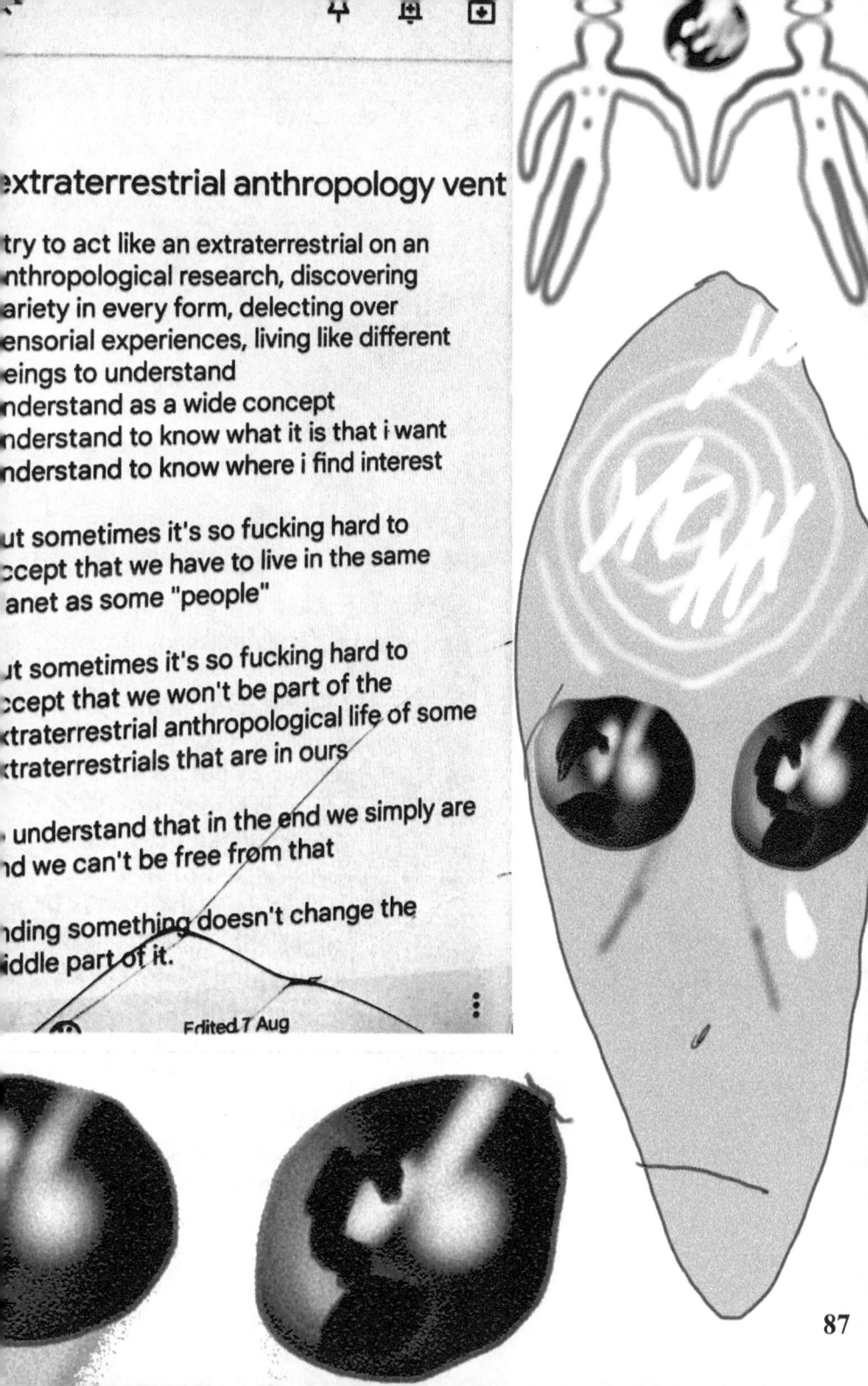

extraterrestrial anthropology vent

try to act like an extraterrestrial on an
anthropological research, discovering
variety in every form, delecting over
sensorial experiences, living like different
beings to understand
understand as a wide concept
understand to know what it is that i want
understand to know where i find interest

but sometimes it's so fucking hard to
accept that we have to live in the same
planet as some "people"

but sometimes it's so fucking hard to
accept that we won't be part of the
extraterrestrial anthropological life of some
extraterrestrials that are in ours

understand that in the end we simply are
and we can't be free from that

finding something doesn't change the
middle part of it.

Edited 7 Aug

ceasing to exist. the stop of being. doe
free you from having been.

there are few choices, and, as an
extraterrestrial, observing humans is so
sad, yes languages but no communicat
the silence that is hoped to say more th
words obviously doesn't say shit
and then two people are silent and the
coordination between them can't be th
and the choices that can be made whic
are few can't be made in synchrony
and those humans end up seeing
coincidences as miraculous when they
could be in higher frequency if true fee
were actually voiced
or maybe not voiced because as the
"human" in the anthropological experie
communication is so damn difficult,
because it's not just a two part ricoche
the ricochets move and communicatio
morphs into pure and fluid adaptation,
constant.

COMMUNICATION

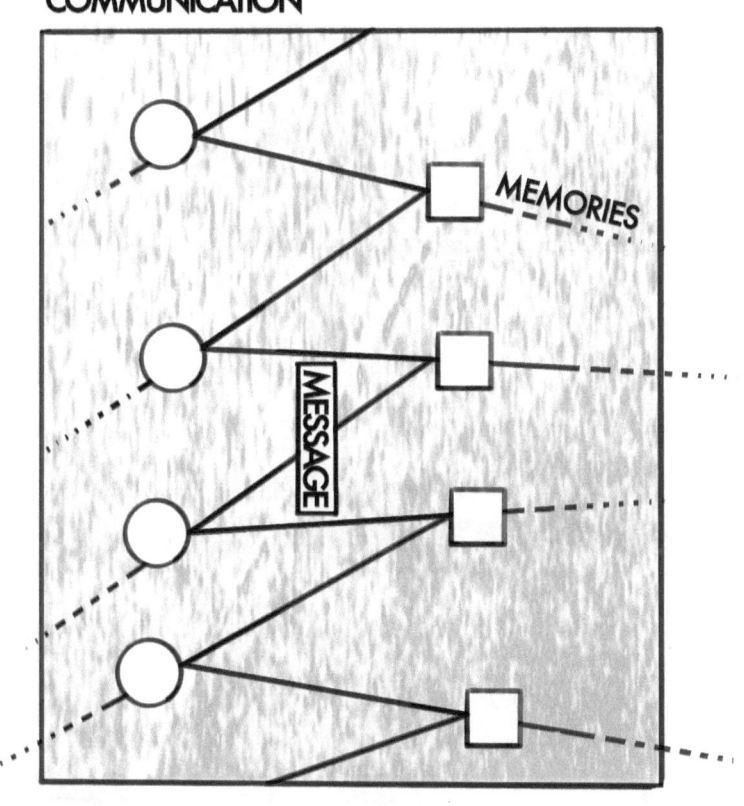

constant.
like a game of pong charged with information and emotion
messages aren't punctual, the residues present in short and long term memory are what messages are. depends on the capacity of adaptation of each member of the communication zigzag to determine the longevity and therefore intensity in the reception of a message

damned we are, or not, inconclusive studies
22:29.3.8.22

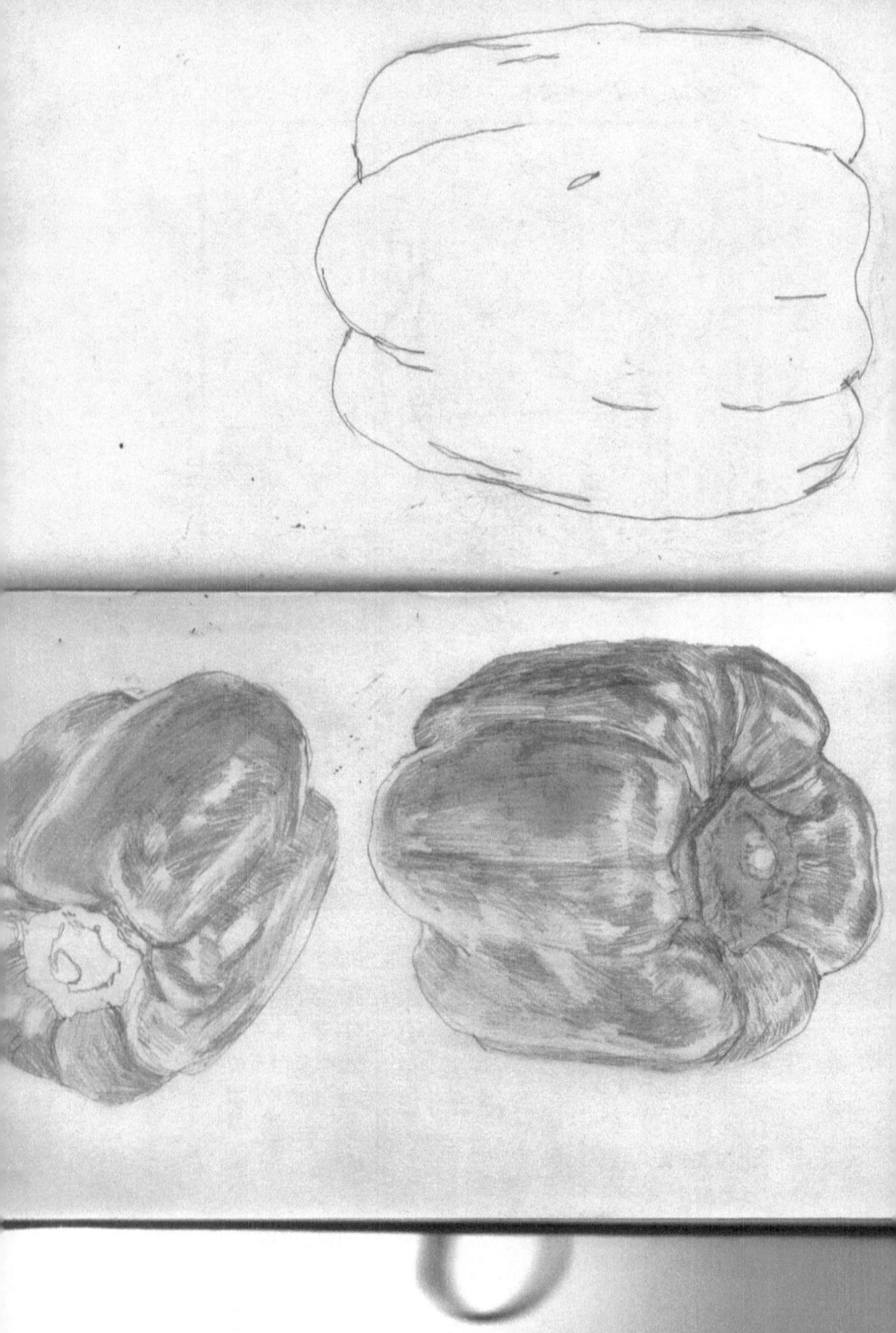

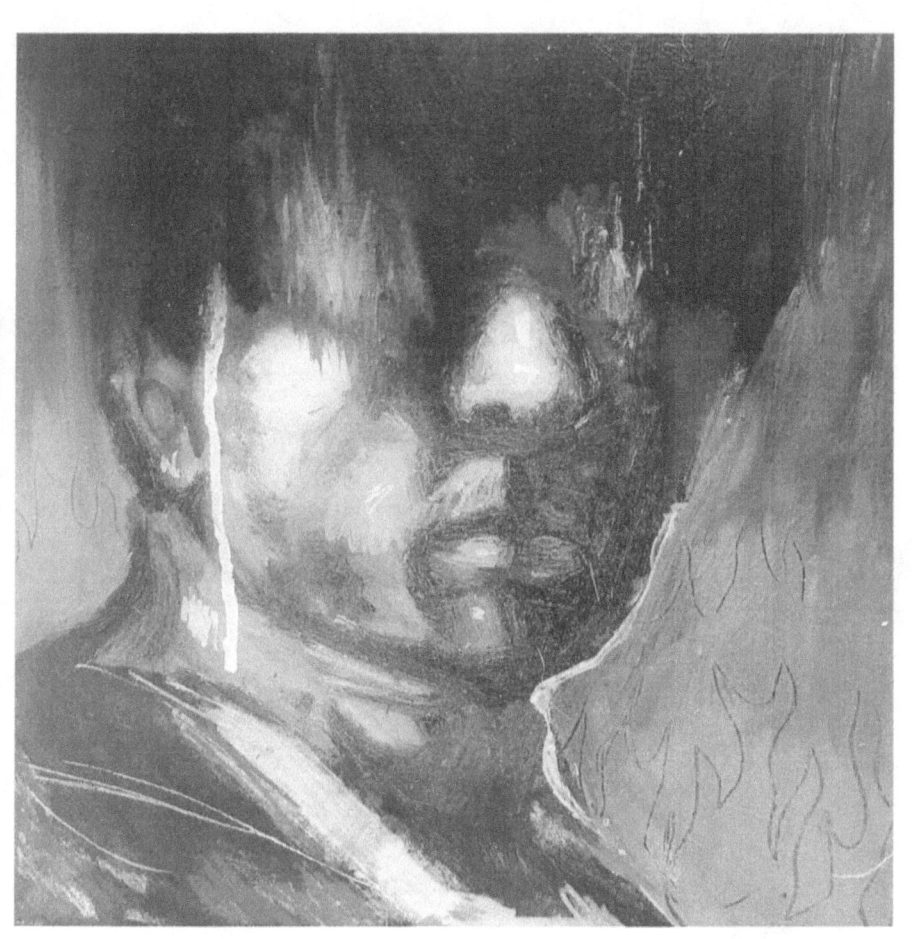

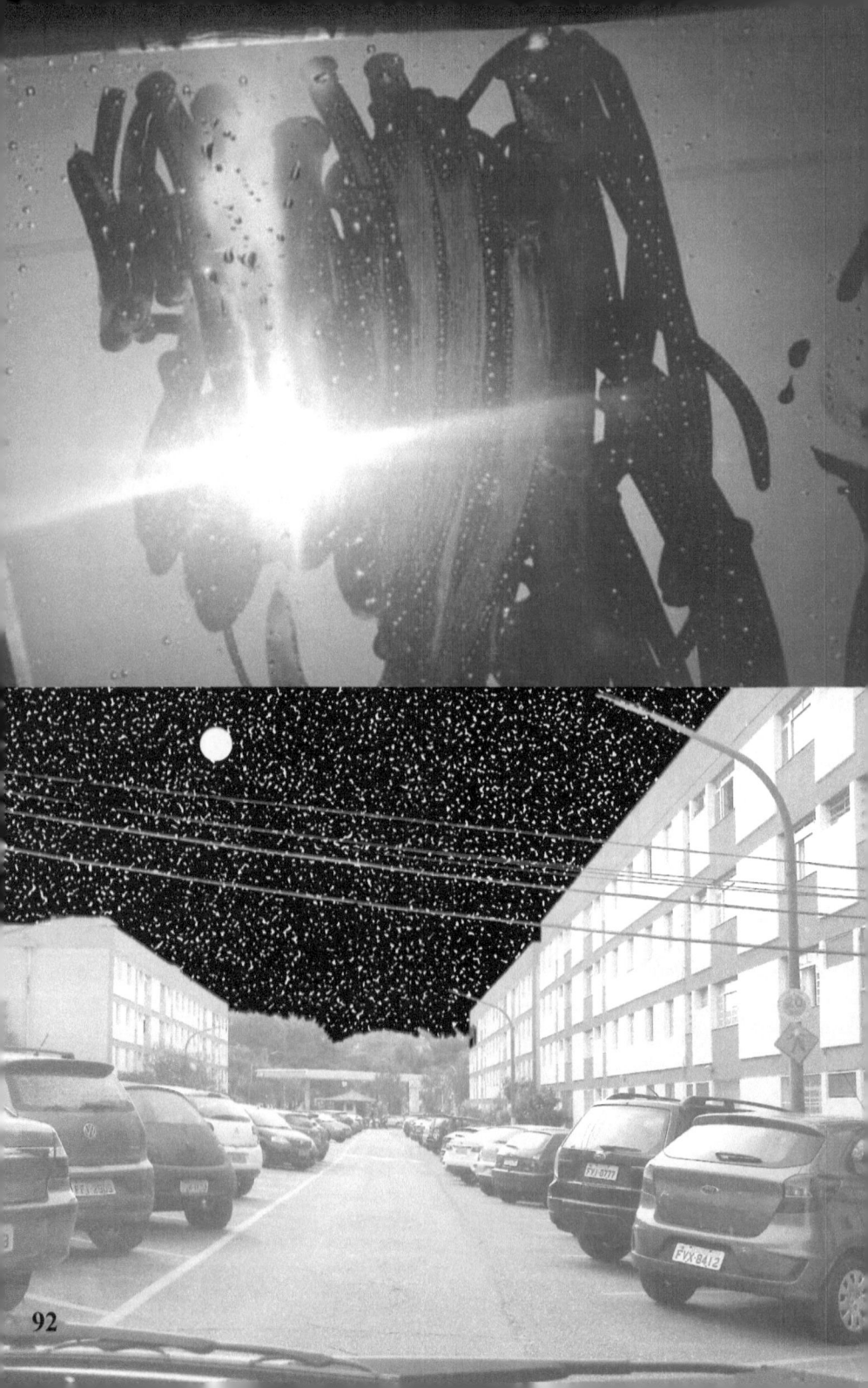

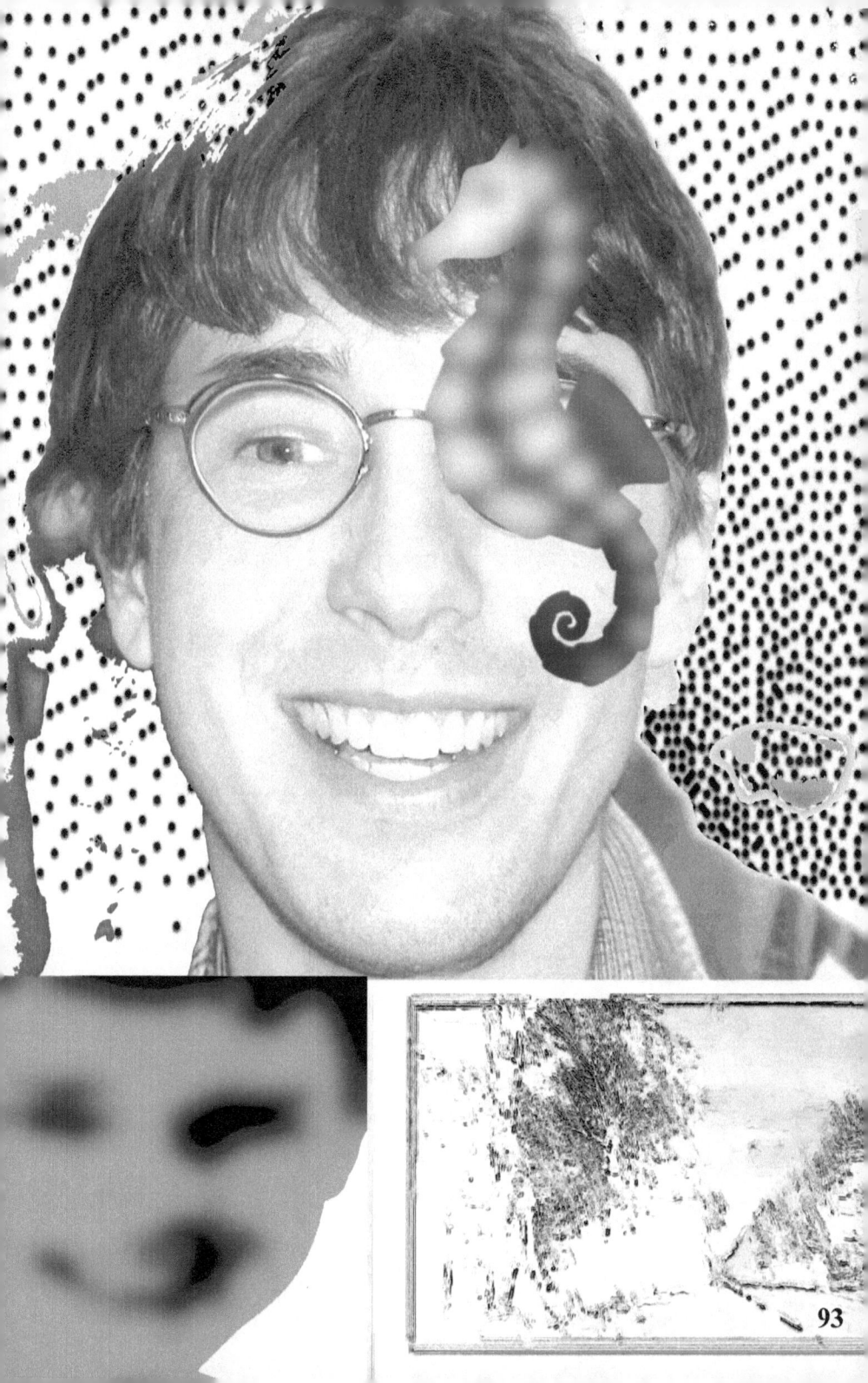

93

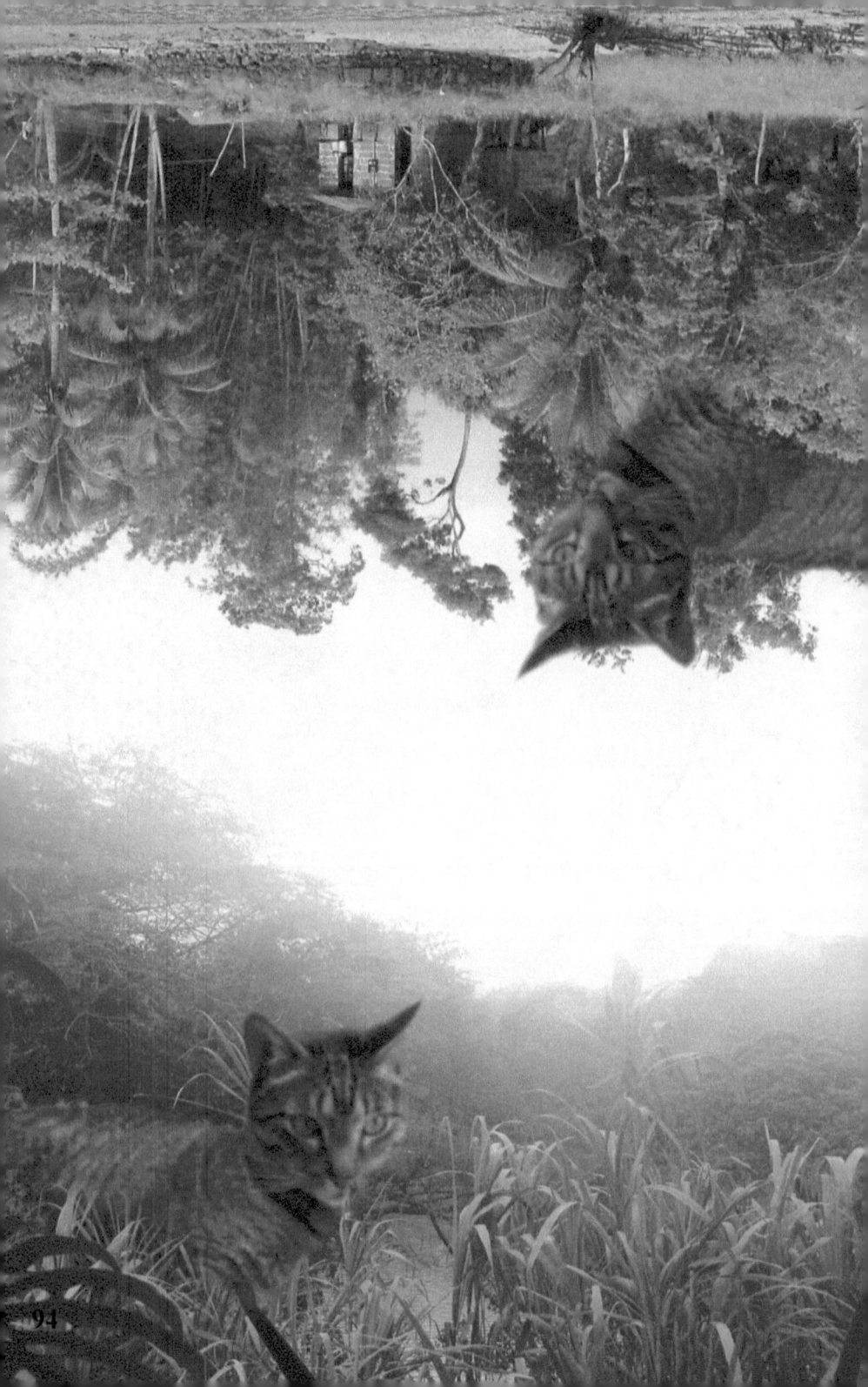

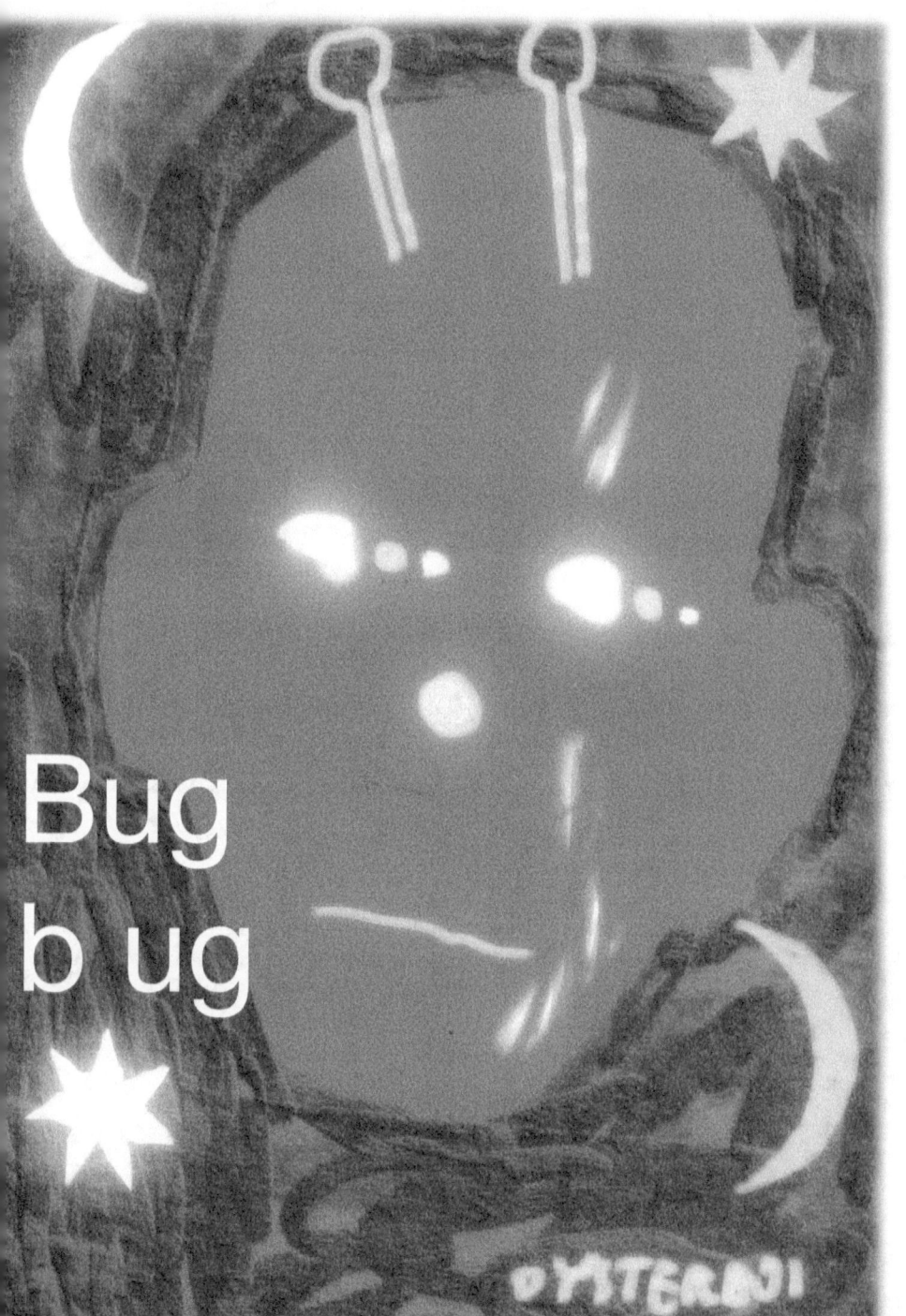

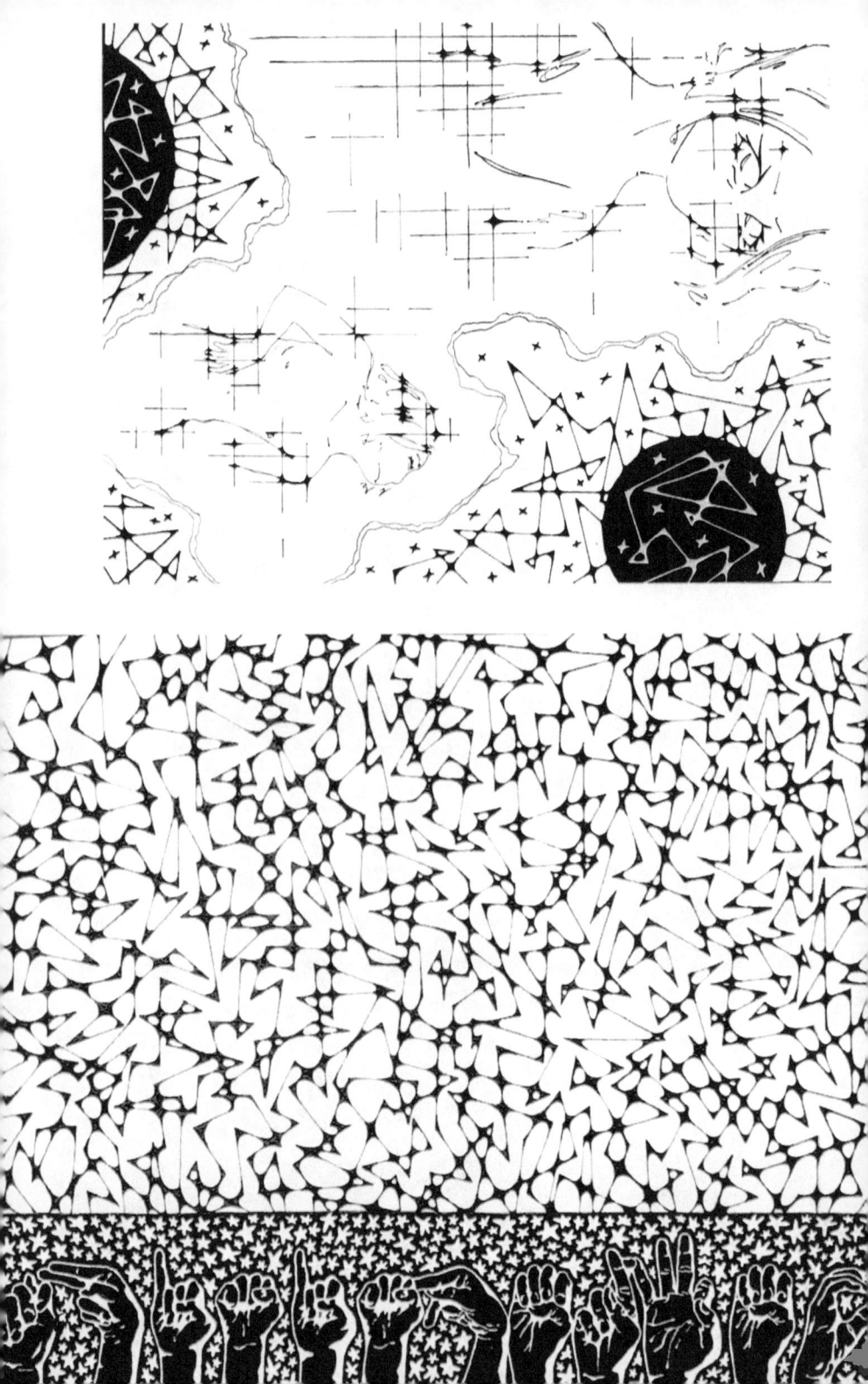

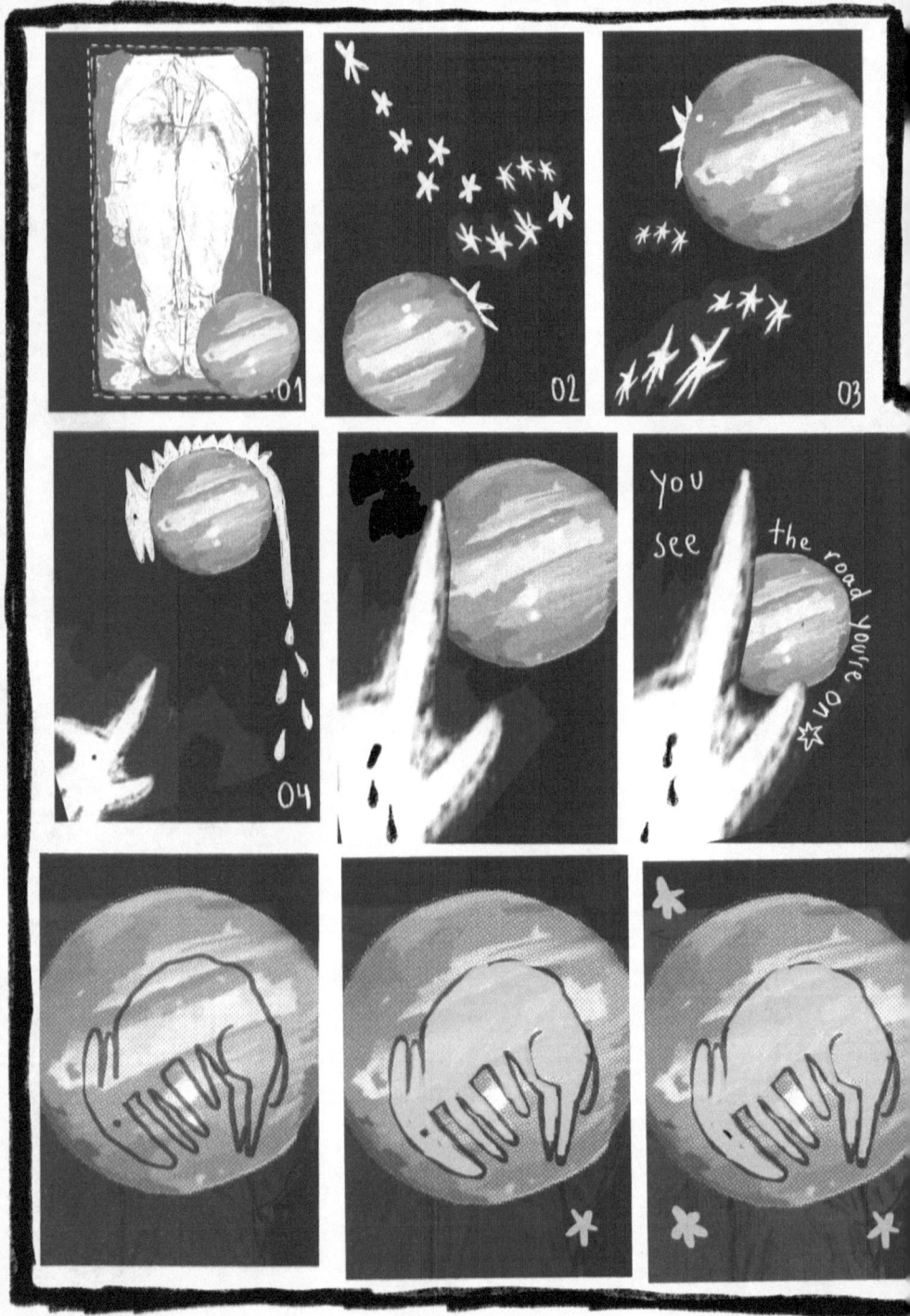

101

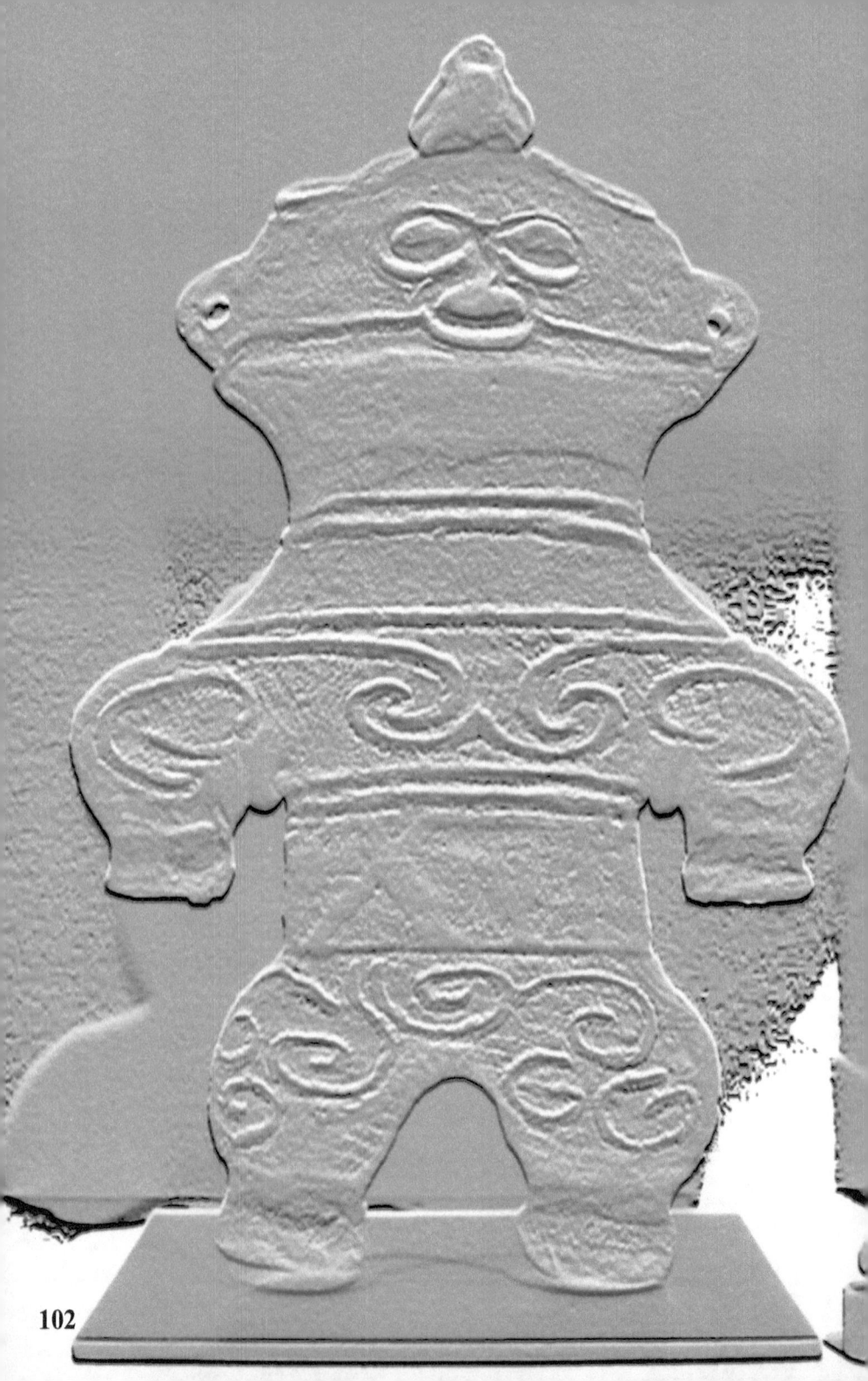

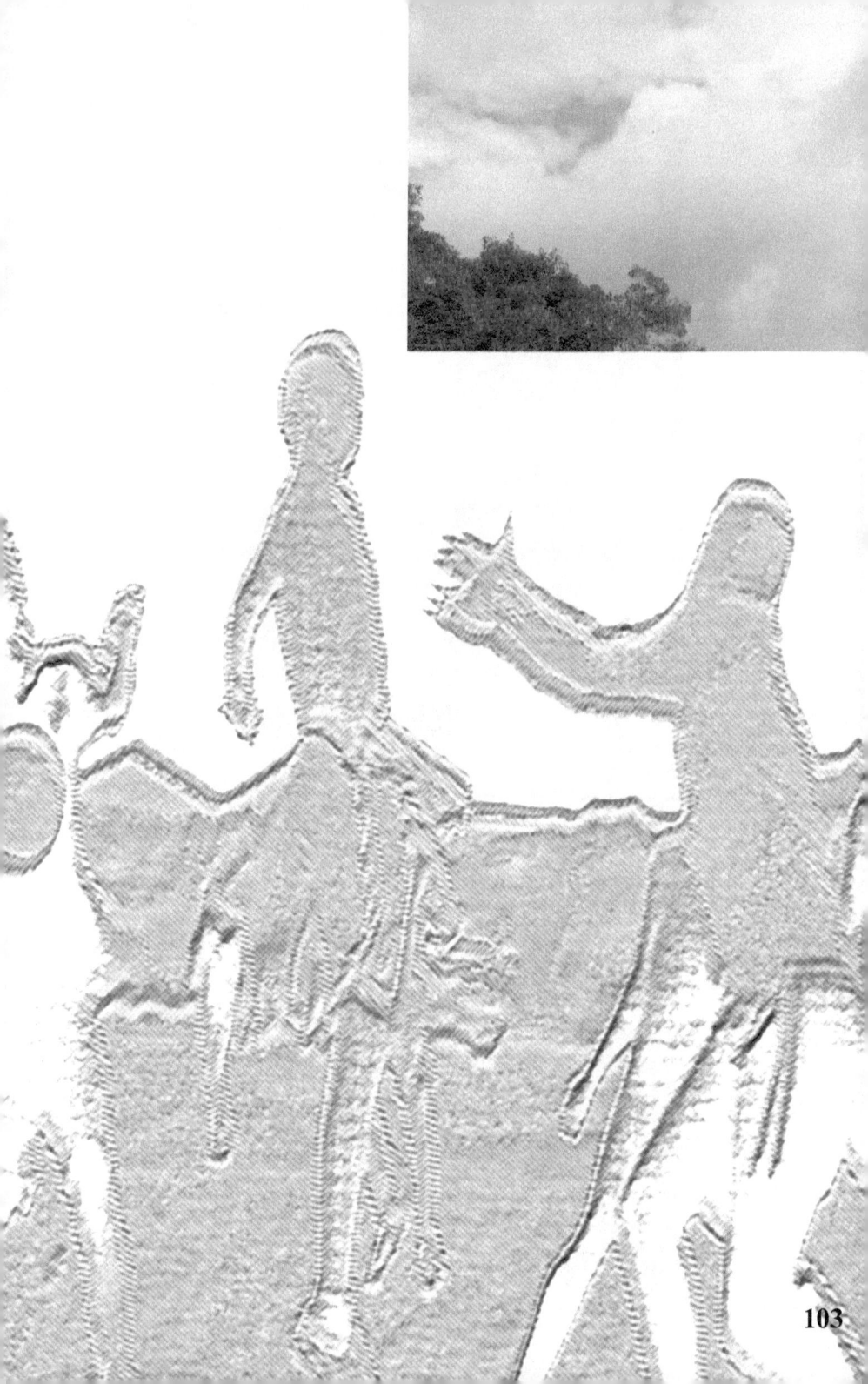

Describo a mi más sincero yo como una flor. Una rosa ahora marchita por todos los intentos inacabados de florecer, por el anhelo de ser un nuevo concepto, el cual solo dejó un vacío, una ausencia del ser, creando un exceso de pena que acabó asfixiándose. Me marché, eliminando así cualquier tipo de esperanza, pero dejando residuos que darán paso a la nostalgia. Espero florecer la siguiente primavera, evitando vivir en unos recuerdos que solo me harán odiarme, espero no guardarme rencor.

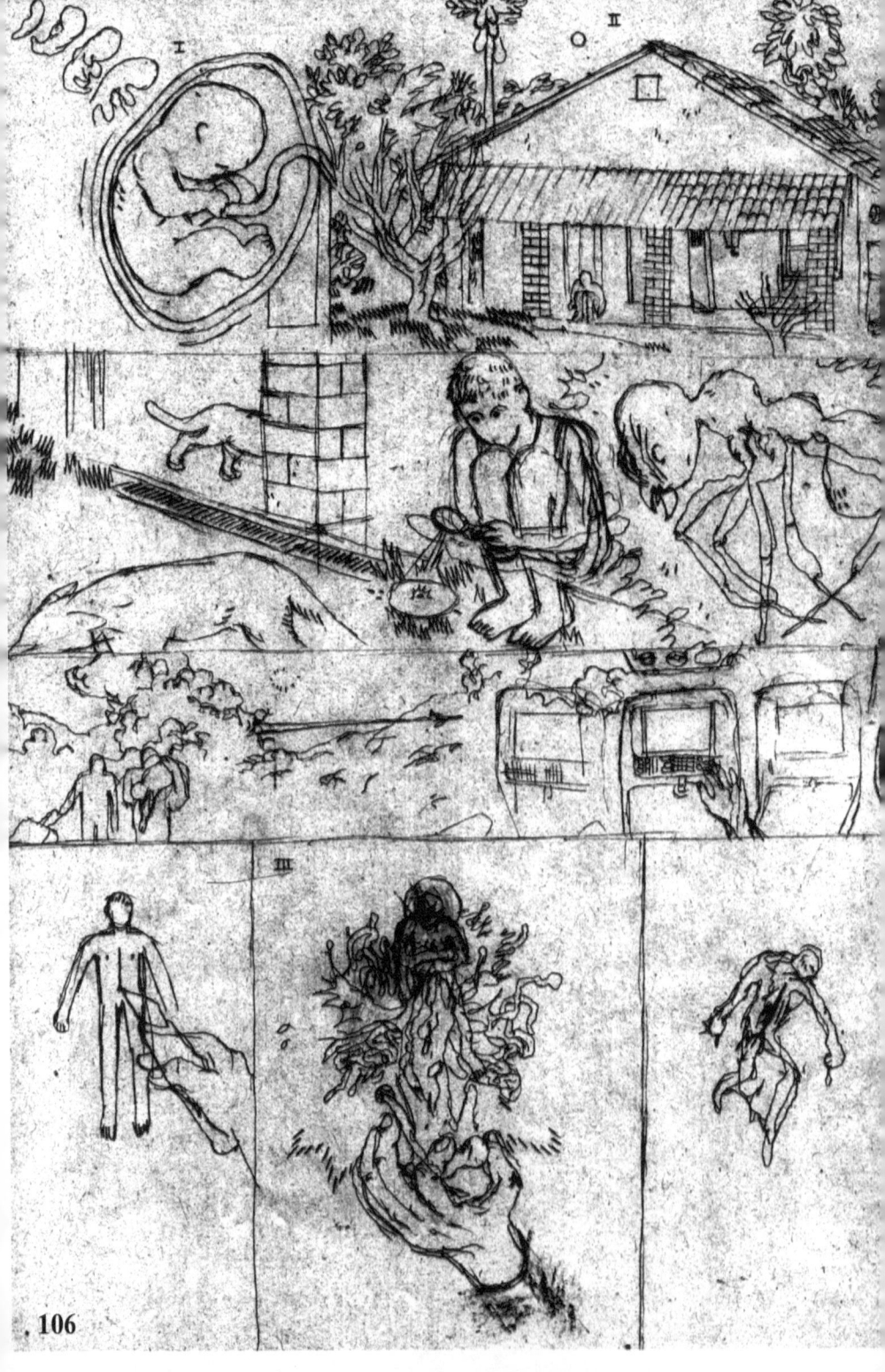

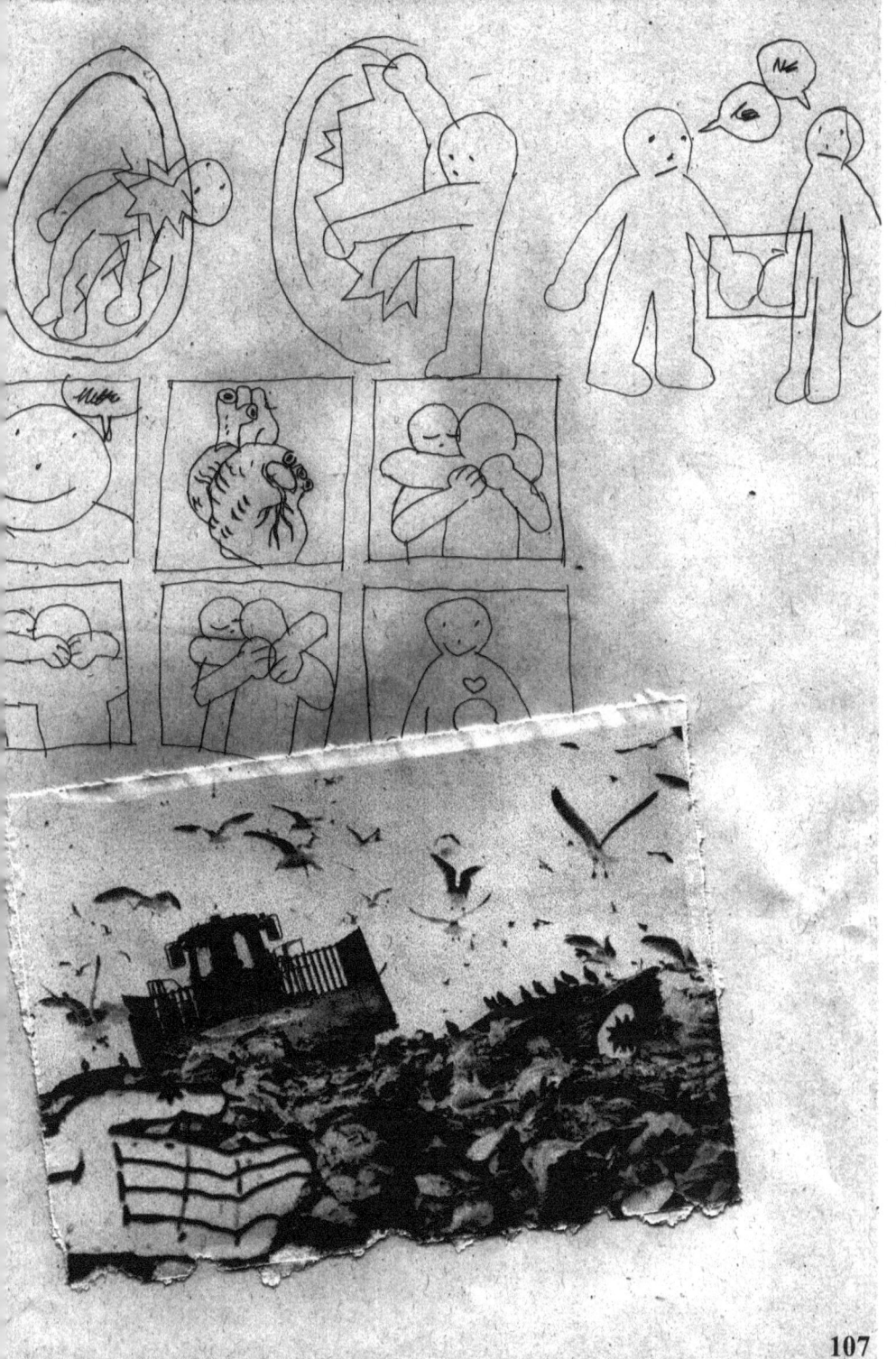

 im crying

Yesterday at

06:37

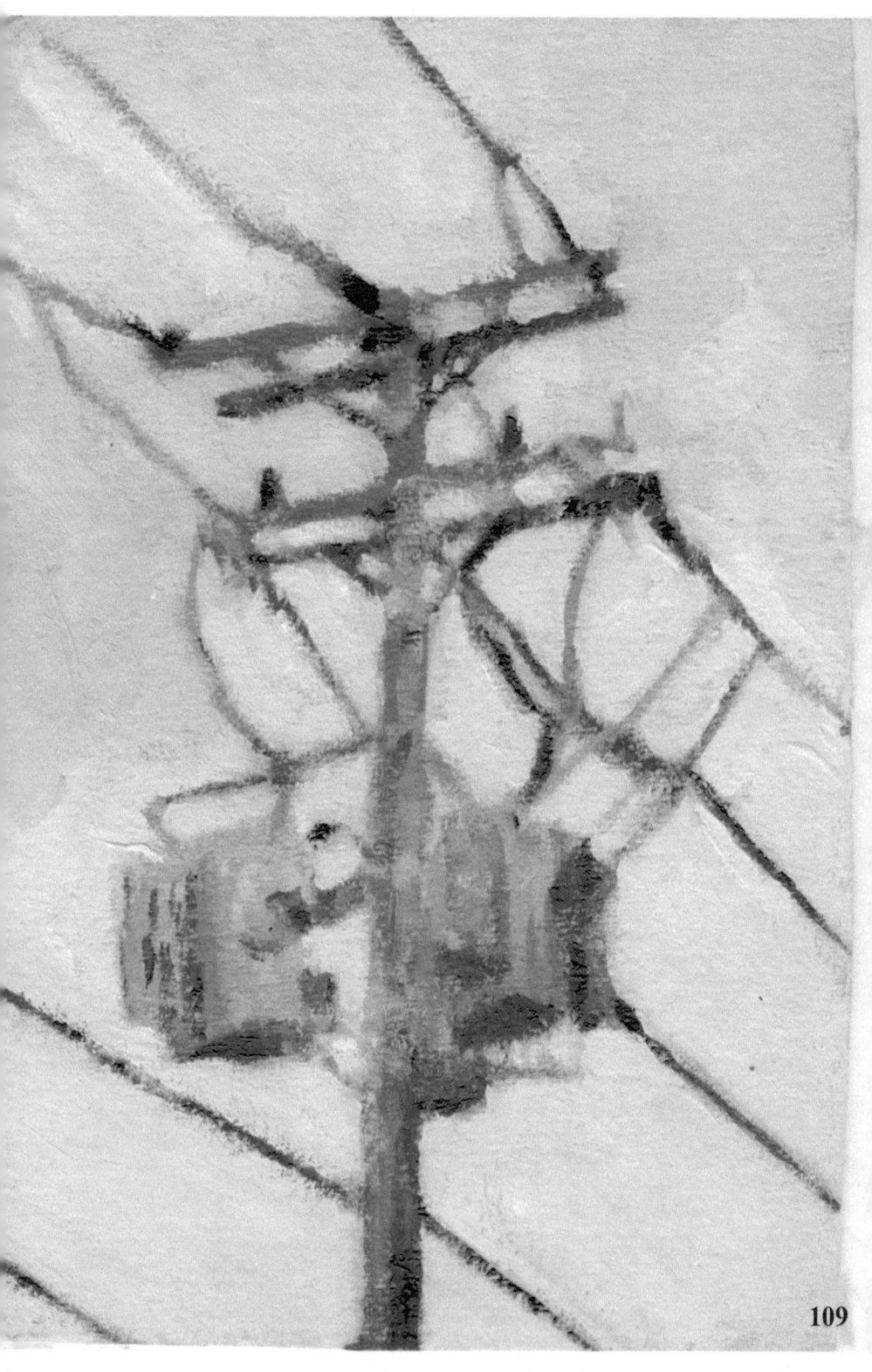

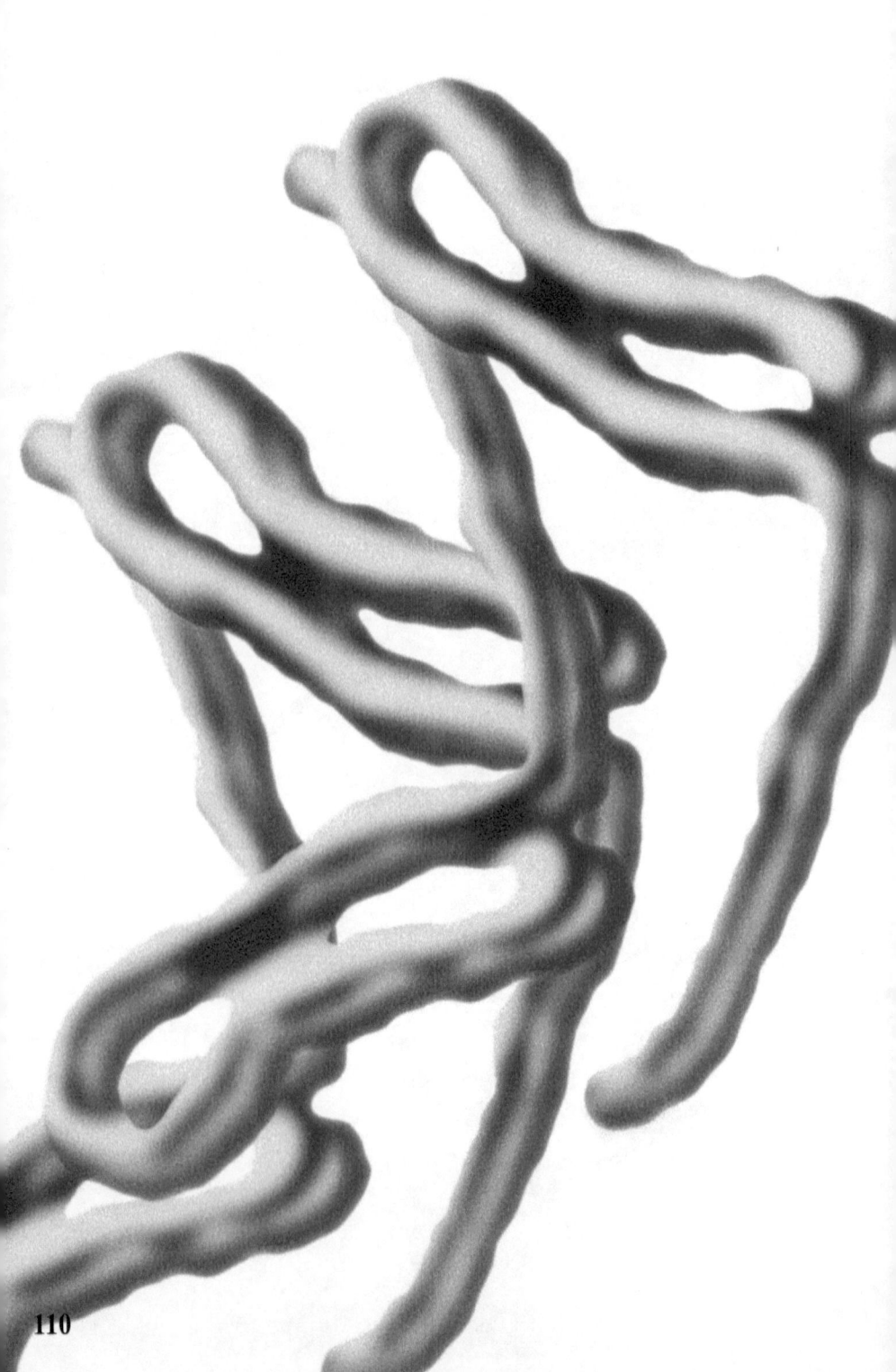

MOTLEY

MOTLEY MAG
WILL HAVE A
THIRD
VOLUME

MAG

www.ingramcontent.com/pod-product-compliance
Lightning Source LLC
Chambersburg PA
CBHW020923180526
45163CB00007B/2862